Black & White PORTRAIT PHOTOGRAPHY

Helen T. Boursier

AMHERST MEDIA, INC. ■ BUFFALO, NEW YORK

With special thanks to the two wonderful men in my life, my husband Mike and our son Jason. Mike printed all of my photographs, and both guys put up with my long hours at the computer. Also, this book would not be the same without all the photographers who so willingly shared their ideas and their images. Thank you.

Published by:
Amherst Media, Inc.
P.O. Box 586
Amherst, NY 14226
Fax: (716) 874-4508

Publisher: Craig Alesse
Senior Editor/Project Manager: Richard Lynch
Associate Editor: Frances J. Hagen
Editorial Assistant: Michelle Perkins

Photos by: Richard and Kristen Barnes, Michael and Helen Boursier, Paul Bobkowski, Dean Collins, Jay Goldsmith, Horace Holmes, Roy Madearis, John Ouellette, Cheryl Richards, Julia Russell, Martin A. Seefer

Cover Photo by: Paul Bobkowski, Richard Barnes, Helen Boursier and Dean Collins

ISBN: 0-936262-61-3
Library of Congress Card Catalog Number: 97-77174

Printed in the United States of America
10 9 8 7 6 5 4 3 2 1

Table of Contents

Introduction

Black & White Portrait Photography offers an inside look at how working photographers earn a living photographing portraits in black & white. The images included are as diverse as the photographers who created them. You will meet photographers whose work is classical and follows the work of old masters. You will also meet contemporary image-makers who continually experiment with new lighting styles and processing techniques. Some photograph almost exclusively in black & white. Others do most of their personal work in black & white and their commission work in color. All have a passion for black & white portraiture.

Each chapter is self-contained. You may read the chapters in the order they are presented, or you can skip from one chapter to another to suit your portrait interests. A list of equipment each photographer uses is provided in the section where you first meet the photographer. Just as you will see a variety of portraiture styles, you will also see a wide range of photographic equipment, film and paper preferences.

For example, one photographer uses a makeshift light he bought at a garage sale. Another works exclusively with available light on location. Another uses window light and a simple reflector. And another uses every piece of photographic lighting equipment imaginable.

Black & White Portrait Photography also gives special insight on how to add black & white to your color repertoire. There are suggestions on how to prepare your clients for better portraits and help them to select the right portrait product. You will also learn the pros and cons of working with a lab or doing it all yourself.

"The images included are as diverse as the photographers who created them."

CHAPTER ONE

Learning to "See" in Black & White

Anyone who has ever watched a black & white movie on television and then switched the channels to a color show will tell you that one medium is distinctly different from the other — one has color, the other does not. Unfortunately, in the world of black & white portrait photography, what is

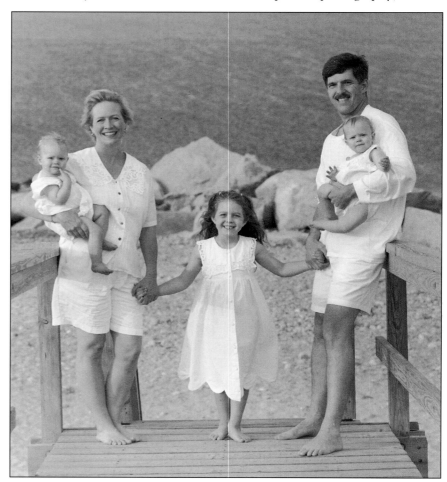

1-1: Black & white film can render soft gray tones in soft light. This image was taken just as the sun was setting. A color photograph taken at the same time would make the water bright blue. As a black & white image, the tones are all neutral, keeping the focus of the image on the family and not on the environment. Photo by Helen T. Boursier.

1-2 (opposite page): This black and white photograph of a little blond-haired girl in a white dress on the beach was taken just as the sun was setting through haze and rain. Photo by Helen T. Boursier.

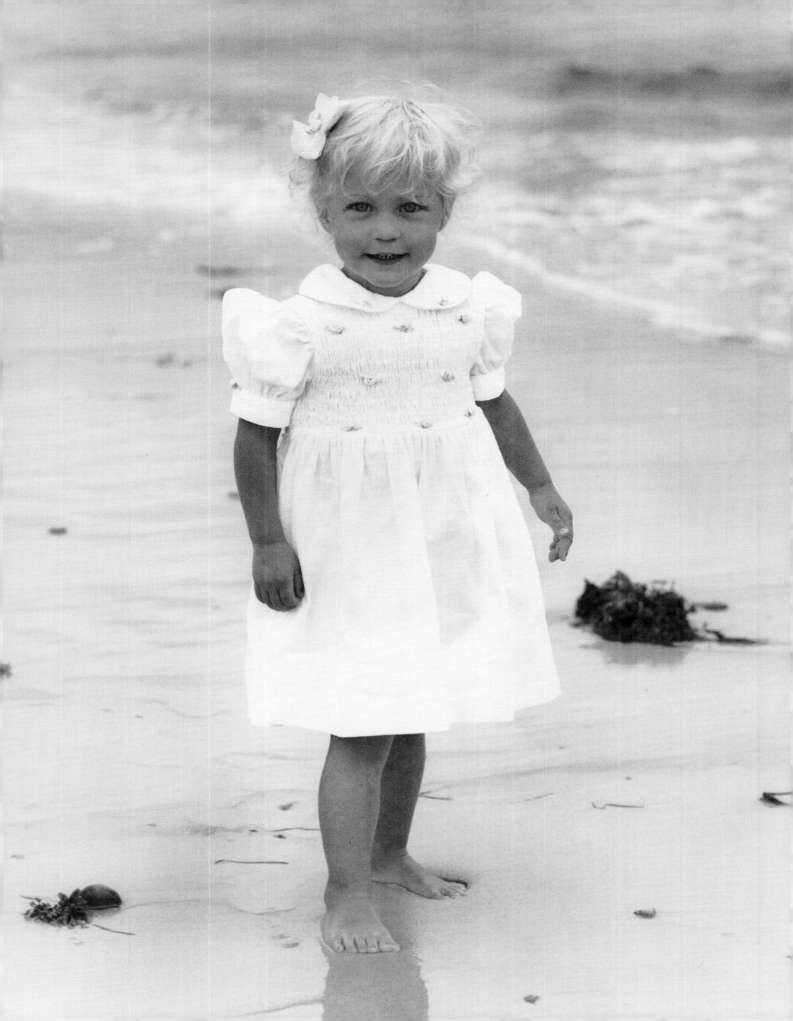

"You must learn to see the world in gray tones..."

obvious on television is not so obvious in photography. You must learn to see the world in gray tones, and then help your clients to do the same.

Mixing and Matching Color with Black & White

Some portrait photographers offer both color and black & white, and they ask clients to choose between the two before the photography session. However, it is not cost effective to photograph the same images in both color and black & white. Also, the best expressions might be on the wrong film.

It is very important to match the location to the medium. Photograph a sunset on the beach in black & white if the client wants soft light. If the client wants beautiful sunset colors, then use color film. If the client wants vibrant autumn foliage, color film works best.

1-3: Line and design play an important role in leading the viewer's eyes across a black & white photograph. The late afternoon sun creates an interesting light pattern throughout the image. Photo by Helen T. Boursier.

Contrast and Black & White

Color film records form while black & white film records lines and tone. An outdoor scene with middle gray tones is not as visually interesting as a black & white image because there are no strong blacks or whites to give it contrast. The grays look muddy without those elements of contrast.

You can't keep all things equal — clothing, lighting, setting — and simply switch back and forth between color and black & white. You must train your eye to "see" the difference between an image made for color and one ideal for black & white.

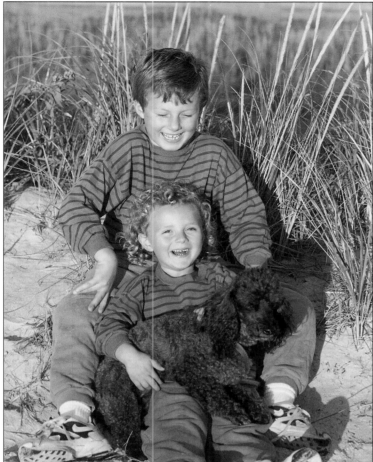

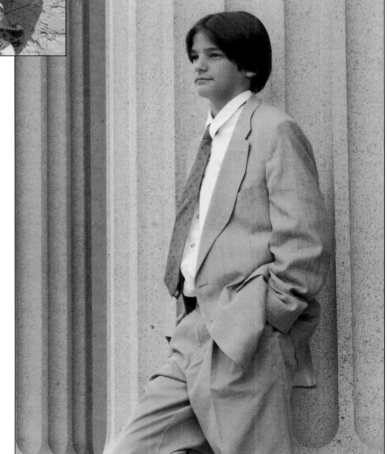

1-4 (above): The broad light of the late afternoon sun hitting the subjects directly in their faces creates a vibrant, energetic image. The blue striped shirts would be distracting in a color image, but the deep gray in the black & white image keeps the eye drawn to the boys' faces. Photo by Helen T. Boursier.

1-5 (right): This high school portrait is the perfect example of the right expression on the wrong film. The image really captures the "going into high school" mood, but it was taken with color film. Overall, the tonal range of the color printed on black & white paper is quite good, but the skin tones in the shadow area are a little too dark. Photo by Helen T. Boursier.

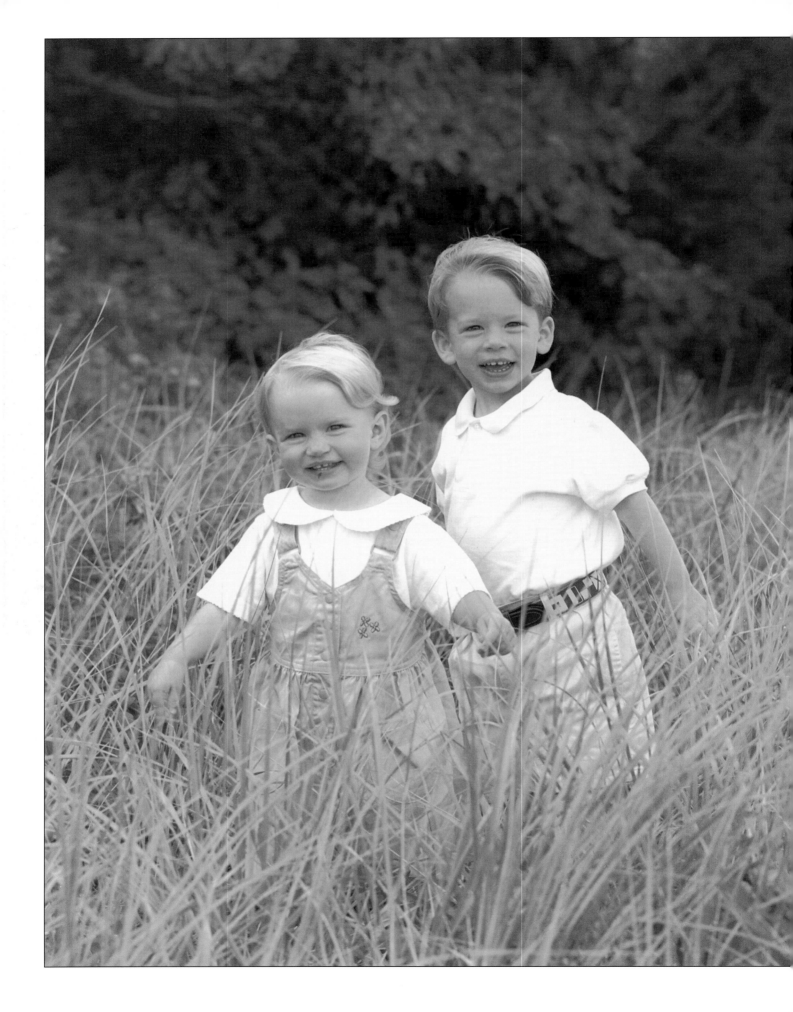

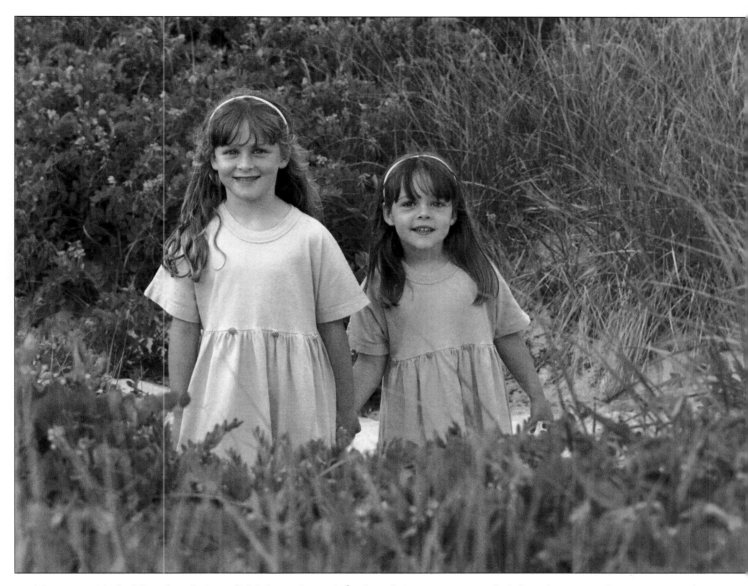

The two girls holding hands in a field (see photo 1-6, above) is composed of all middle gray tones as a black & white, and doesn't come close to the impact created in the original color image. The girls are wearing bright pink dresses, the field is rich green beach grass with deep purple flowers, and the lighting is the warm glow from the sun just setting over the ocean. You could make this colorful scene a strong black & white image by adding contrast in the girls' clothing, like the photo of the brother and sister in the beach grass (photo 1-7, opposite page).

The same concept applies to the two photographs of the children and the church doors. Black & white needs contrast. A rich brown door of a church is basically the same gray tone as the girl's pink dress (see photo 1-8, page 12). That creates a very gray image.

The graphic elements of the black & white church doors offer much more impact with the three siblings dressed in navy and white. It is not a "color" image because there is little color in the scene (see photo 1-9, page 12). Continually train your eye to see the differences yourself so you can better educate your clients on making the correct choice.

1-6 (above) & 1-7 (opposite page): Compare these two photographs. The image above could make a strong black & white image by adding contrast in the girls' clothing. The image to the left shows good contrast makes a better black & white picture. Photos by Helen T. Boursier.

1-8 (left) & 1-9 (below): Compare these two photographs. In the image to the left, more contrast is needed in the girl's dress so the subject does not blend in to the background. The image below shows how better contrast will have more impact. Photos by Helen T. Boursier.

1-10 (opposite page, top): It is important to match the location to the clothing to the lighting to the medium. Photo by Jay Goldsmith.

1-11 (opposite page, bottom): For this photo, the client requested black & white for this fall foliage scene. The client's wish was to show the relationship between her children. Photo by Richard Barnes.

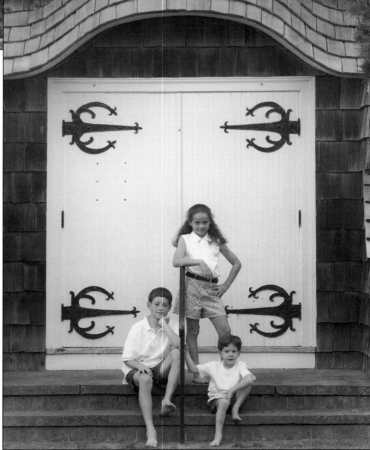

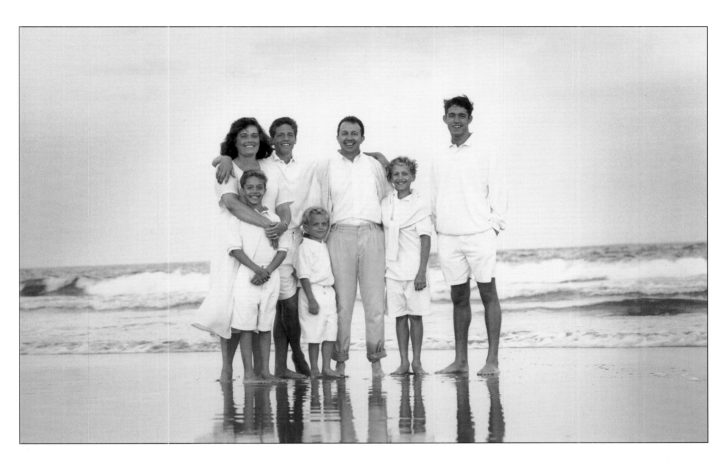

CHAPTER TWO

Preparing the Subjects

"...speak positively when referring to black & white."

Be sure to speak positively when referring to black & white. It is easy to say "we just do black & white," or "we only do black & white." However, both explanations make it sound like black & white is second rate and color is better. You'll emphasize your black & white speciality much better when you say, "We work exclusively in black & white."

Introducing Black & White Work to Your Clients

During the beginning of phasing black & white into your regular color routine, it will help your clients if you have a sample which shows one image in color and a similar image beside it in black & white.

Consider offering a slide show to introduce clients to your work, including several "before and after" images in color and black & white. Choose color samples that are correctly lit, well-posed and pleasing to the eye. When the black & white slide immediately follows the same subject in an almost identical pose, it is easy to point out the differences to the new client.

Point out how "busy" the color shot looks compared to the black & white. These slides help clients to visualize clothing, because one false assumption is that it doesn't matter what you wear for a black & white portrait.

Clothing for Black & White Portraits

A successful black & white portrait begins with the clothing. You can pour your energy into photographing a beautiful subject under ideal lighting conditions at a stunning location, but the image will be ruined without the correct clothing. "Correct" depends on the objectives of the photographer and the client. The key is to work out the details with the client before the session.

Many clients travel several hours for a beach portrait session but don't always have time to make a planning session prior to the shoot. Consider using a portrait planning folder or "press kit" which gives ideas on what to wear, how to stay relaxed and what to expect of the photographer during the session. Be sure to include samples of children and family group portraits in the planning folder.

Because dressing correctly can make or break a portrait, a planning kit should offer the following specific suggestions:

2-1: A white on white "high key" works outdoors, too. Blond hair, white shirt, white porch rail, and white background make the face the darkest element of the photo, and therefore a dominant part of the image. Photo by Helen T. Boursier.

- Clothing should complement, not dominate, the portrait.

- Busy patterns, bold stripes and trendy styles overpower the people in the portrait.

- Choose solid colors (or subtle prints) and classic clothing styles.

- For balance in the tonal range, have everyone wear either light, medium, or dark colors.

- Light could include white, cream, faded denim or any color pastel.

- Medium means tan, postman blue, or any middle range color.

- Dark colors include red, navy, purple, brown, evergreen.

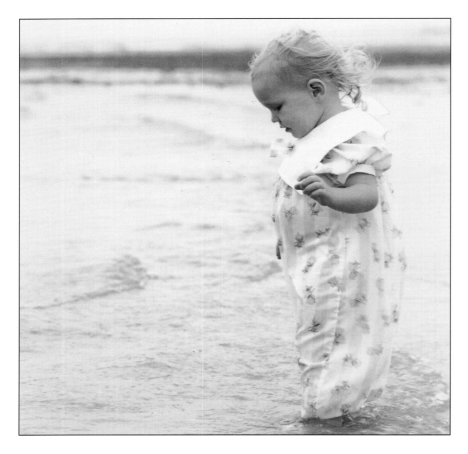

2-2 (left): Photographers generally advise against stripes and prints in group portraits, but small prints and subtle stripes look fine for individuals, particularly children. Photo by Helen T. Boursier.

2-3 (below): The white tops balance with the white sand. The medium tone of the jeans is repeated with the medium tone of the beach grass behind. Photo by Helen T. Boursier.

2-4 (opposite page, top): A classic studio high key with light clothing against a light background. Photo by Jay Goldsmith.

2-5 (opposite page, bottom): Advance planning is important to prepare your clients. Extra hair spray helps. Avoid collars that flap in the breeze. You might want to take along some bug spray. Photo by Helen T. Boursier.

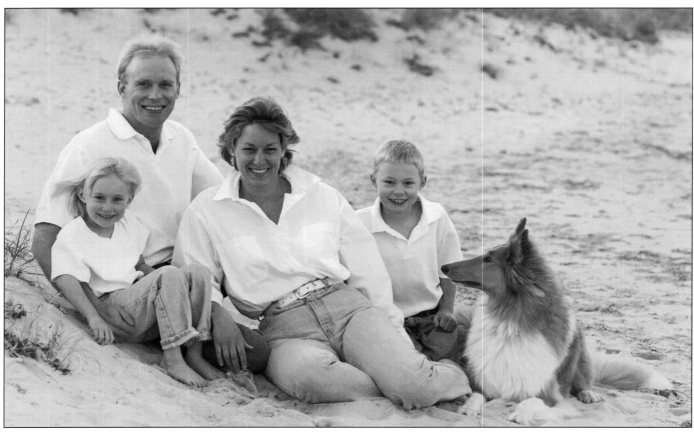

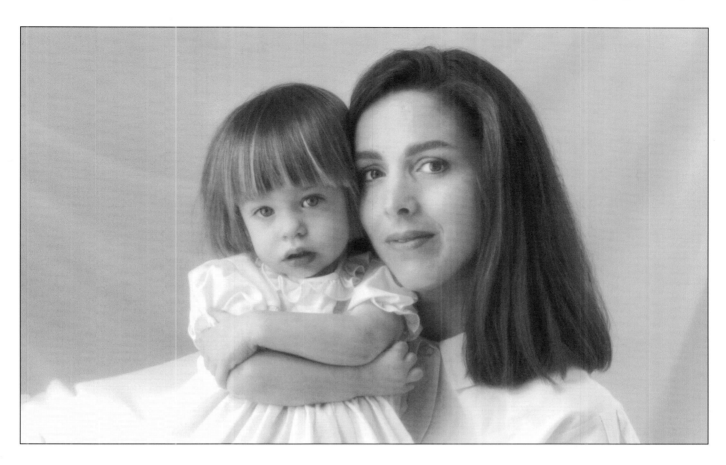

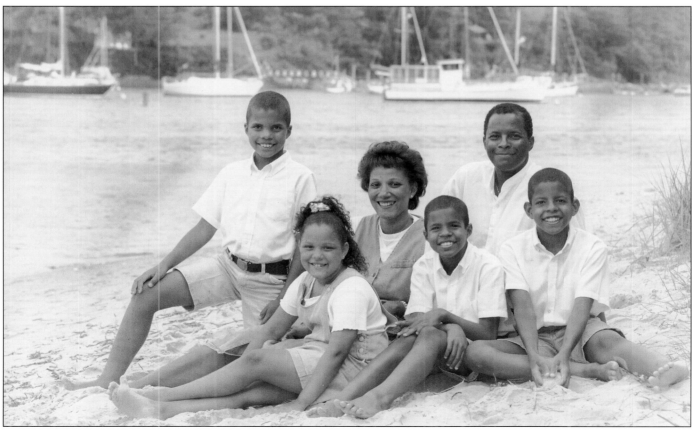

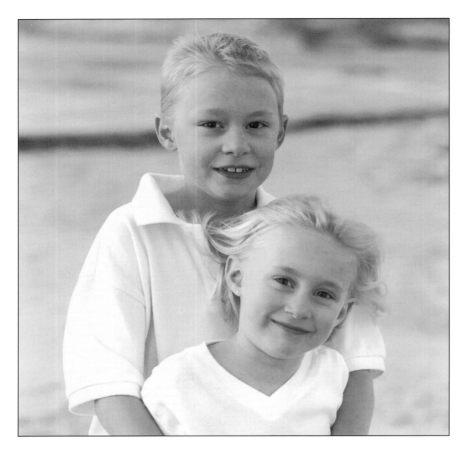

2-6 (left): Some mothers think blond-haired children shouldn't wear light colors because they will look "washed out." In fact, the opposite is true. The light clothing, light hair and light setting all draw the eye right to the children's faces. Photo by Helen T. Boursier.

2-7 (below): The mother in this shot said everyone did white at the beach, so she opted for a "low key" portrait and had her family wear dark green tops. The medium gray tones on the sand and water behind the subjects keep the focus on the family. Photo by Helen T. Boursier.

2-8 (right): The plaid dresses add to the image here because all three girls are wearing the same dress. It would not work if only one or two were wearing plaid. Photo by Helen T. Boursier.

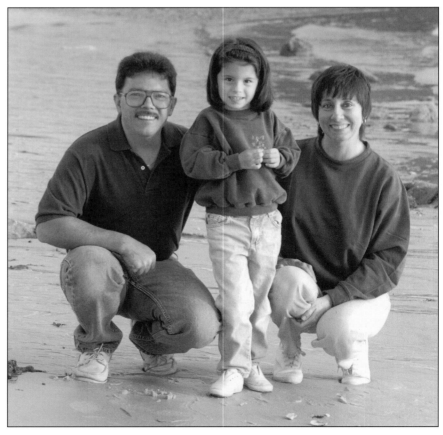

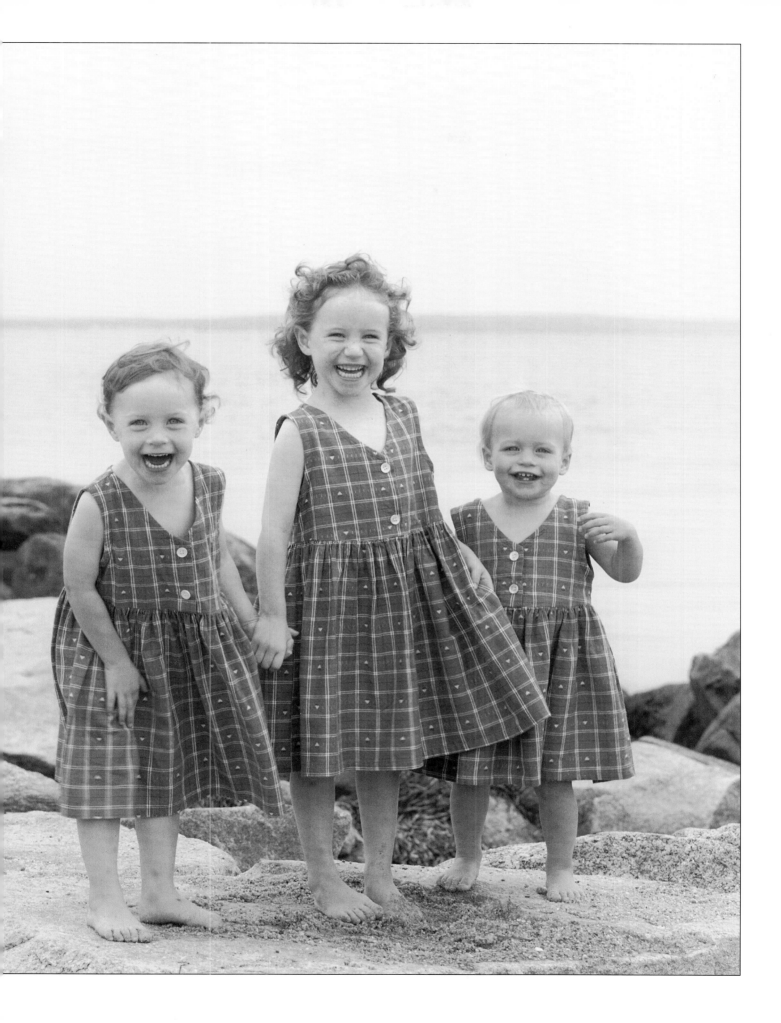

2-9 (left): Clients bring their favorite clothes to the portrait sessions. It's the photographer's job to help the clients pre-visualize what those clothes will look like photographed in black & white. Otherwise, the client may not realize the pattern in a favorite plaid sweater will "jump out" at the viewer. Photo by Michael L. Boursier.

2-10 (below): The man's dark shirt keeps the image balanced and draws the viewer's attention to the subjects' faces. This is a classic low key image. Photo by John E. Ouellette.

2-11 (right): Prepare clients by asking if there is something the subject could include in the image that would have special meaning to the person receiving the photograph. Photo by John E. Ouellette.

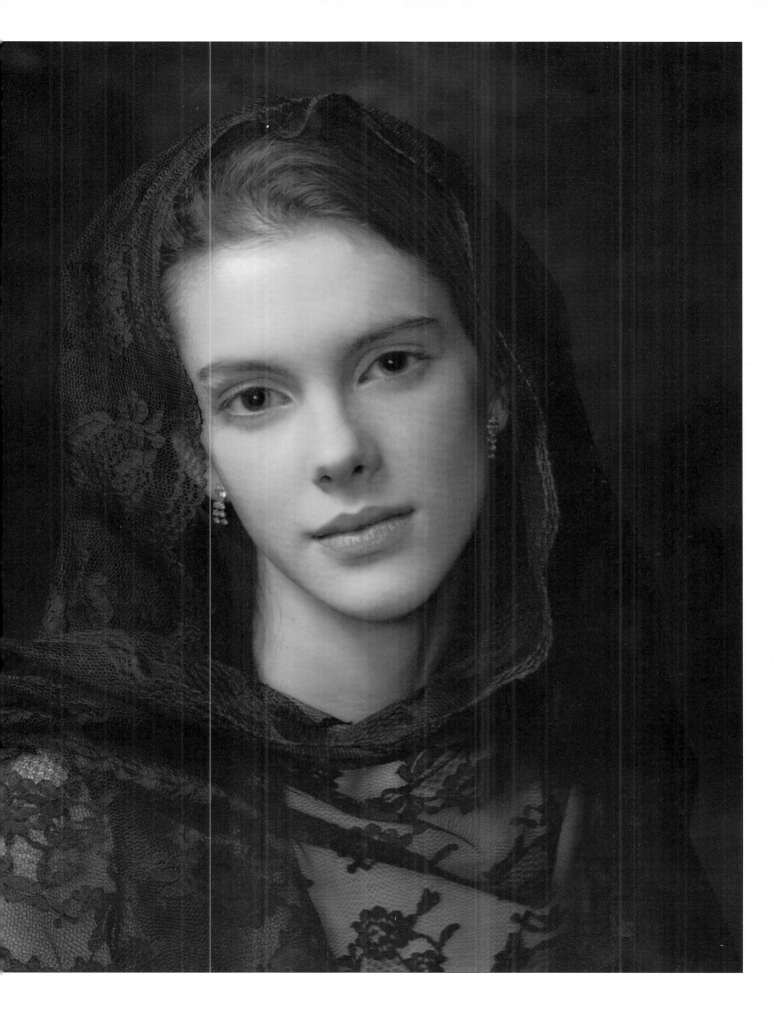

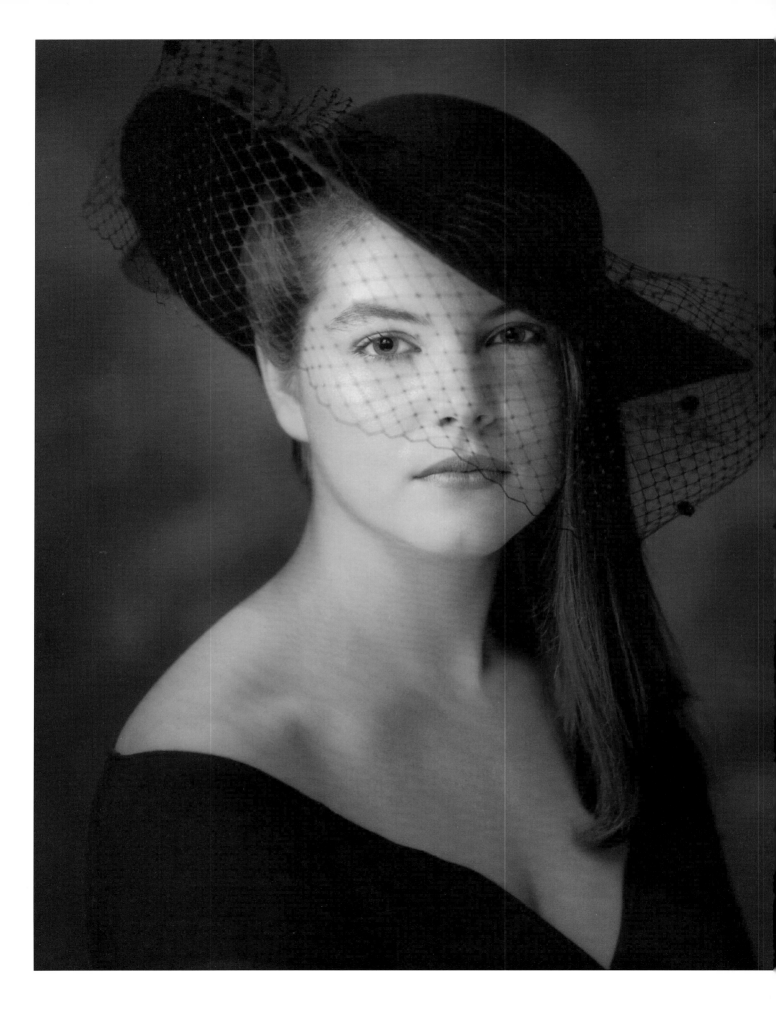

Kristen Barnes conducts planning consultations for her husband and business partner, Richard, at Barnes Portrait Design. During this session, she creates a hospitable atmosphere. Barnes gives a slide presentation which covers the settings and styles offered. She emphasizes how important the correct clothing choices are for a portrait by using slides to show good versus bad examples. "You can talk about clothing all you want, but until the client sees what you're talking about, they won't necessarily be able to visualize," she explained.

Photographer John E. Ouellette considers timing. For example, John prefers to photograph a male subject in the morning when the subject is clean-shaven.

The next issue is clothing. "I find out the purpose of the photograph. If it is going to be a gift, I ask the subject if the person receiving the portrait gave my client something special to wear that could be included in the portrait." He stresses that simple clothing styles are better, and like many portrait photographers, he tries to get the subject to avoid prints or stripes.

According to Ouellette, the ideal high key (light setting) subject is a woman with light hair who will wear a light blouse or sweater. The ideal low key (dark setting) subject has dark hair and will wear dark clothing. "I prefer the off-the-shoulder 'portrait' neckline for women, and a dark suit, white shirt and dark tie with a bit of color in it for men. I emulate photographers from the 20s and 30s who worked with movie stars."

When Ouellette does the initial telephone consultation with a client, he discusses tone and contrast. "I use the word contrast because I don't want too much contrast between the hair and the clothing and the background. If you add a second subject, you want to keep the same tonal range of grays. Basically, we talk about shades of gray. The client may ask about wearing red, and I make sure she understands that red might look dark when she expects it to look bright."

Whether you meet with your clients a week, a day, or a few moments before the session, help your clients select the best clothing. When you and your clients work together, you can create images that reflect the right personality and style.

"...simple clothing styles are better..."

2-12: (left) This is a classic low key subject with a "portrait" neckline. Photo taken by John E. Ouellette.

CHAPTER THREE

Making Your Work Unique — A Matter of Style

Black & white portraiture seems to bring out everything; from the classical to the contemporary. Black & white offers many choices. You might like warm skin tones, another photographer likes skin tones printed cool. You might like soft focus images while another likes crisp, sharp ones.

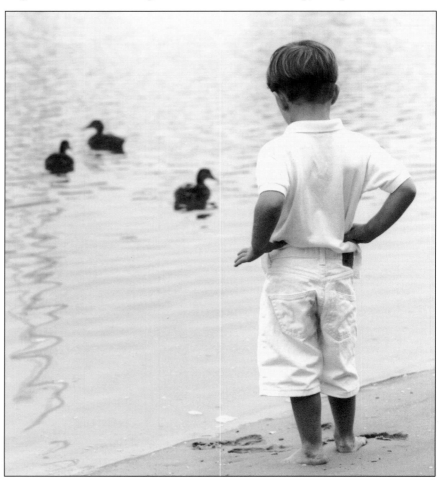

3-1: The key to a successful "candid" is to make it look "casually perfect" and not like a snapshot. Photo by Helen T. Boursier.

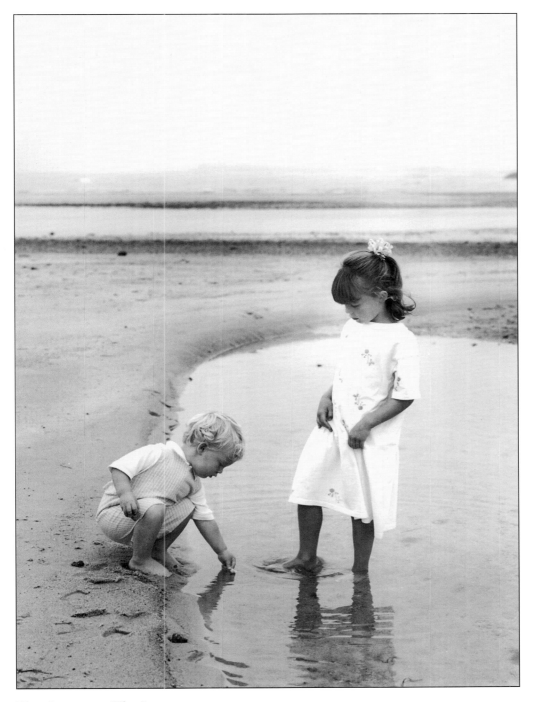

3-2: Natural poses, like this one, are actually carefully staged to get the subjects in just the right places, doing just the right thing, at just the right time. Photo by Helen T. Boursier.

Equipment Choices

There are many equipment choices available to you: high speed film, low speed film, fiber versus RC (resin coated) paper, warm toned versus cold toned paper, dark versus light clothing, and soft lighting versus high contrast lighting.

Camera size also affects style. Do you want a small format 35mm for quick shooting and high speed film choices? Do you want a medium format 2¼ or 6x7cm camera for better wall portrait enlargements with some portability, or will you lug around a large format 4x5 or 5x7 for stunning quality enlargements but less ease of operation?

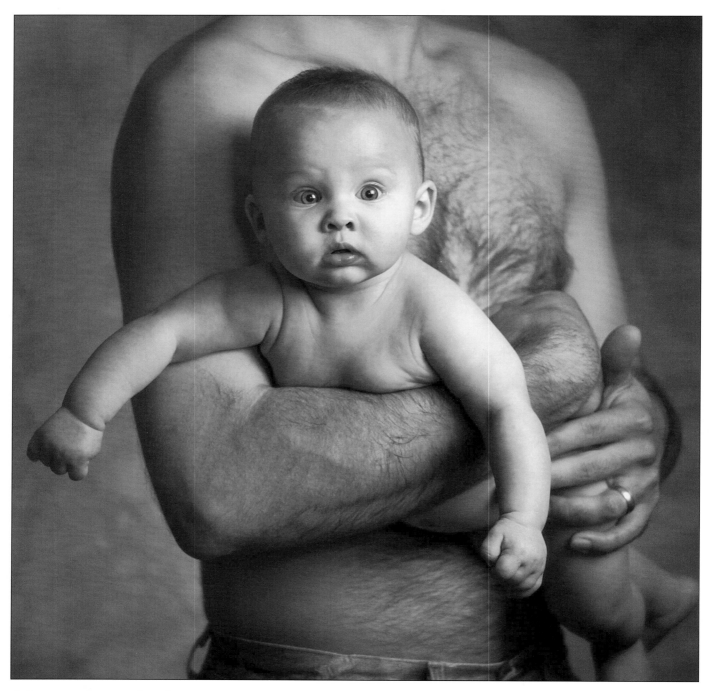

3-3: Many photographers have a "signature" style. Photo by Richard Barnes.

3-4 (opposite page): This classical bridal portrait specialist watches the bride to see how she sits, how she moves and the expressions she uses. Then he duplicates her natural poses within the portrait. Photo by Martin A. Seefer.

Creating a Personal Style

When you add the usual choices of composition, layout, design, location and lighting style, you can put together a style that is uniquely yours. Remember, there is no one right answer. As with all art, style is ultimately a matter of taste — yours and your clients'.

John E. Ouellette describes his work as classical. He uses a warm tone fiber-based paper and prints for very warm tones. He does all the negative retouching on his black & white images himself. He said that retouching produces his signature look: highlights in the nose, cheeks and forehead, and a whitening of the eyes.

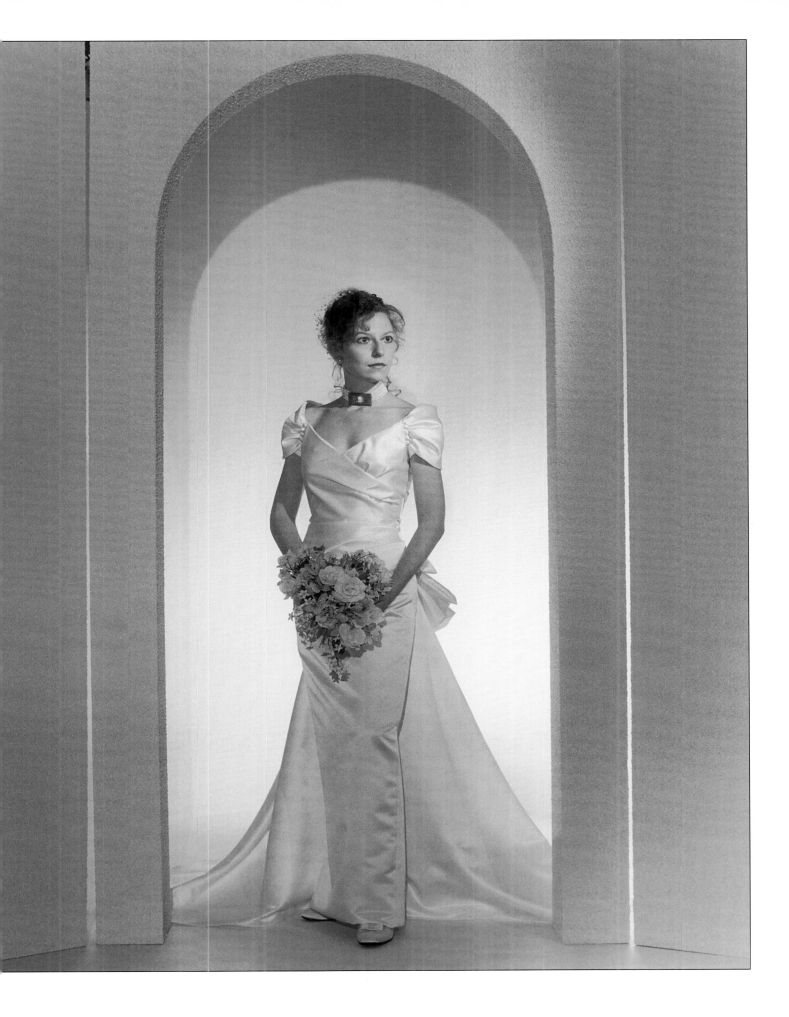

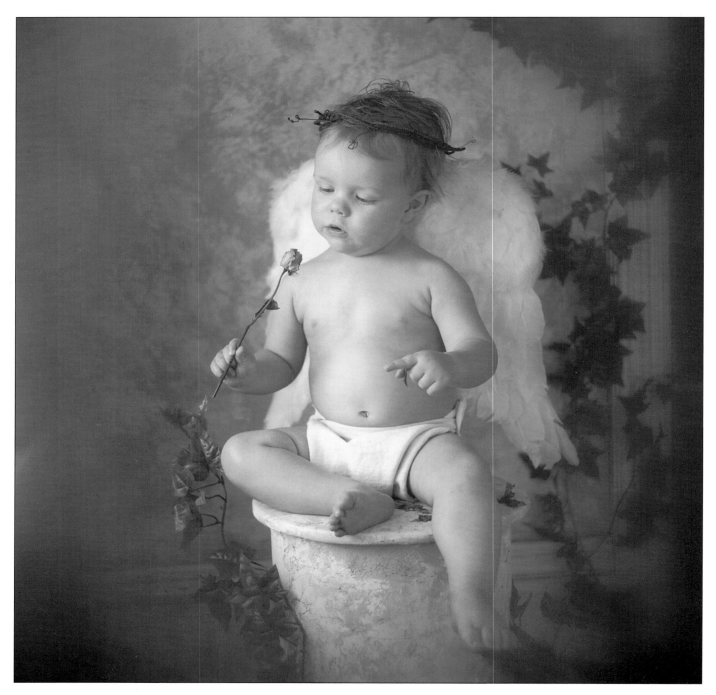

3-5: A window light image — "Petals from Heaven." Photo by Richard Barnes.

3-6 (opposite page, top): Experiment with new techniques. This is a "practice" session with Chuck and Julia. Photo by Paul Bobkowski.

3-7 (opposite page, bottom): An informal portrait taken during an engagement session. Photo by Paul Bobkowski.

John calls himself a low key (dark background) photographer. "I find that a low key portrait is particularly more sensual for a woman, and I look at black & white as having a more sensual feeling," he said. "Color just doesn't have the allure or the tonal ranges that I like."

Martin A. Seefer says that when it comes to style, he lets his heart do the talking. He brings an eye for the subject's personality to his photography. "I don't want the bride to fit the pose, I want the pose to fit the bride."

Paul Bobkowski is respected by his peers for his creative, fine art images. He pushes the limits of creativity to find new ways to capture light, mood and expression.

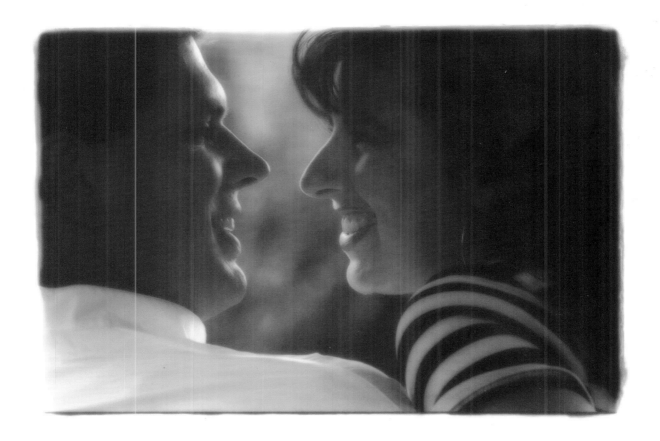

3-8: It often takes a lot of running back and forth between subject and camera to get the right shot, especially when photographing children. Photo by Helen T. Boursier.

3-9 (opposite page): Using his intuition about the best mood to portray with each subject, the photographer emphasizes this subject's expression in the eyes. Photo by John E. Ouellette.

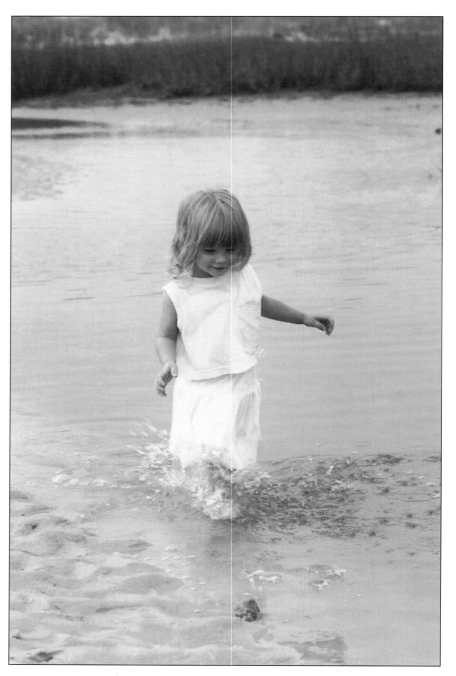

Paul incorporates these images into his personal work. He says, "I do innovative shots for myself. When clients see how creative I can be, they are more likely to give me the freedom to do what I want to do at their wedding or portrait session."

Paul Bobkowski's personal work often includes practice sessions to try out new styles or new photographic techniques. For example, the portrait of Chuck and Julia (see photo 3-6, page 29) was done immediately following a workshop at a Professional Photographers of Massachusetts conference.

Much of Bobkowski's commission portrait work is done in conjunction with a wedding. When he does an engagement session, he knows he needs to come up with a close head-and-shoulders pose that the couple can put in

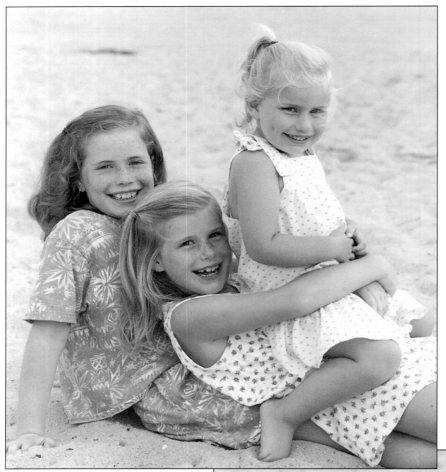

3-10 (left) & 3-11 (below): Instead of worrying about exactly where and how each person is sitting, I encourage people to get close to each other — the love they have for each other will show on the image. Photos by Helen T. Boursier.

3-12 (right): Although "Discovery" looks like it was a personal project, it was actually designed by the children's mother. It is a 30x40 photo that hangs in her office. Photo by Richard Barnes.

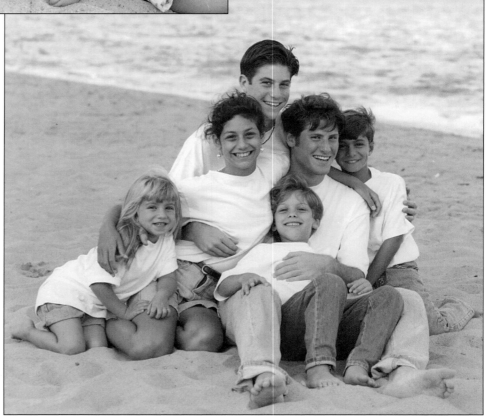

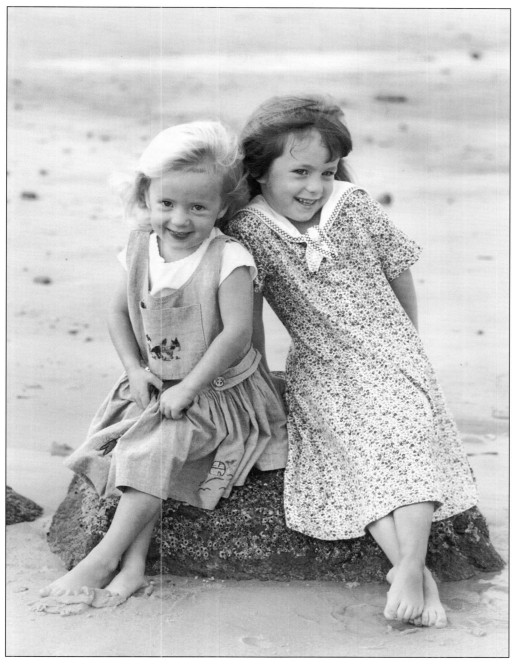

3-14: No matter how many "candid" images I take, the parents seem to always go for the full frame images of their children looking toward the camera. Photo by Helen T. Boursier.

3-13: (opposite page) I strive to photograph the expression that captures the personality behind the face. Photo by Helen T. Boursier.

the newspaper, but he also likes to "let go of control" during the session and allow them to do what they want. "They might be standing on a bridge talking, being romantic and unaware of my presence. Then I might notice the lighting pattern on their faces and get a few close images."

"I give them a general idea of where to sit or stand, and I take an incident light meter reading from the shadow area of their faces. That's it. That's my exposure for that segment of the session. Then I back off and let them do what they want," he explained.

Richard Barnes says he tries to create something timeless. "I want to create a photograph that captures attention because you have to think about it."

"...create a photograph that captures attention..."

CHAPTER FOUR

People Skills for People Portraits

People portraits require people skills. If you don't like working with people, you are better off photographing small products for a commercial catalog. Not only do you need to like people, you need to be willing to work with all kinds of temperaments. Within one family group alone, you could easily interact with both introverts and extroverts. The extroverts might be bossy control freaks or light-hearted people who need to be the center of attention. The introverts might be soft spoken and gentle, or skeptical and quietly opinionated. Good interpersonal techniques are essential.

Getting two brothers to respond together can be tricky because they rarely possess the same temperament. One is usually outgoing and the other reserved. One trick is to ask the two children to "give your brother a hug." The ready photographer can get a spontaneous image that shows the relationship between the two siblings.

Photographing Children

In addition to different personality quirks, each age has its own idiosyncrasies. Most babies can sit up at six months with minor propping and are responsive and expressive. The relationship between mother and baby can be portrayed with the classic madonna image. Consider keeping white wicker baby furniture on hand for propping up little ones. Also, you can tuck pillows behind an infant to get a few images at the end of a mother-child or family group session.

My wicker settee also works for "crowd control" when there are several small children. I carry it in the trunk of my car all summer in case I need an extra second to slow down a wiggly eighteen-month-old or a toddling two- or three-year-old.

Regardless of what props you use or posing you do, you must move quickly with small children. Get on your hands and knees to talk to children at eye level. Get an outgoing child to talk to you. Talk to toddlers and teens in full and complete sentences as if they were adults. Avoid speaking to parents about children within the children's earshot.

"Good interpersonal techniques are essential."

4-1 (above): When it comes to photographing children, go with the flow. This toddler wouldn't let go of mom. The photographer turned that challenge into a unique and cherished image. Photo by Richard Barnes.

4-2 (right): Have a ready supply of props handy. Little ones have a short attention span, so you may need several different props within one session. Photo by Dean Collins.

4-3 (left): This photo captures the animation I use to get my clients relaxed and "natural." Photo by Rob Kneller.

4-4 (below): "Victorian Princess" was created of this seven-month-old at the end of a family session. When the mother called to schedule the session, she couldn't decide whether to do the family of five or just her daughter. Both was the obvious answer. Photo by Helen T. Boursier.

4-5 (opposite page, top): The simple action of holding hands and walking down the beach makes a nice image. It also gives the children something to do when they get a little restless toward the end of the session. Photo by Helen T. Boursier.

4-6 (opposite page, bottom): Porch steps are a quick natural "prop" to keep little ones from running off. Two grandmothers and one mother were just off camera, quickly getting the girls back on the steps every time one lost interest and scooted away. Photo by Helen T. Boursier.

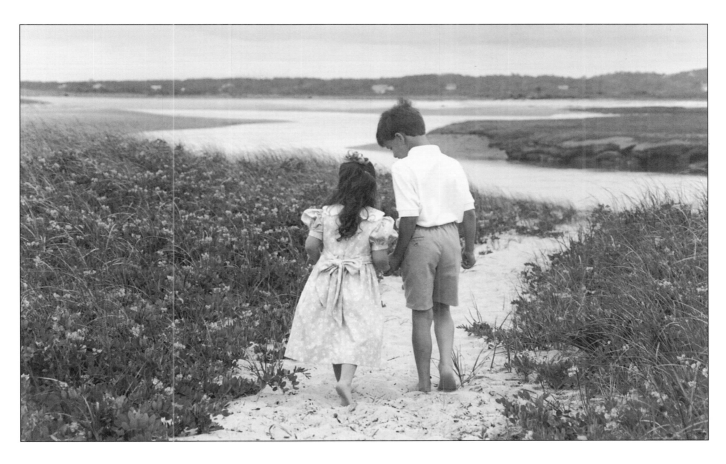

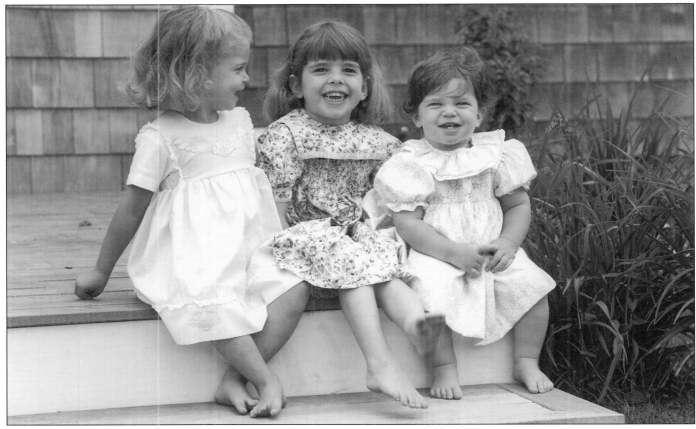

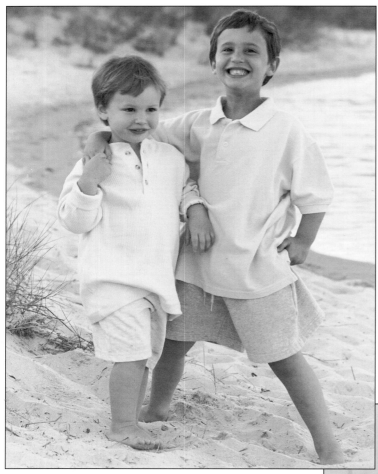

4-7 (left): Getting two brothers to respond together can be tricky because they are rarely the same temperament. One trick is to ask the two children to give each other a big hug. If you are focused and ready, you can get a spontaneous image that shows the relationship between the two siblings. Photo by Helen T. Boursier.

4-8 (below): The classical "madonna" portrait. Photo by Helen T. Boursier.

4-9 (right): This little one plopped right down and couldn't wait for the photography session to begin, but his brother would have nothing to do with being photographed. One responded to direct animation and the other needed quiet activities to distract him from the photography session at hand. Photo by Helen T. Boursier.

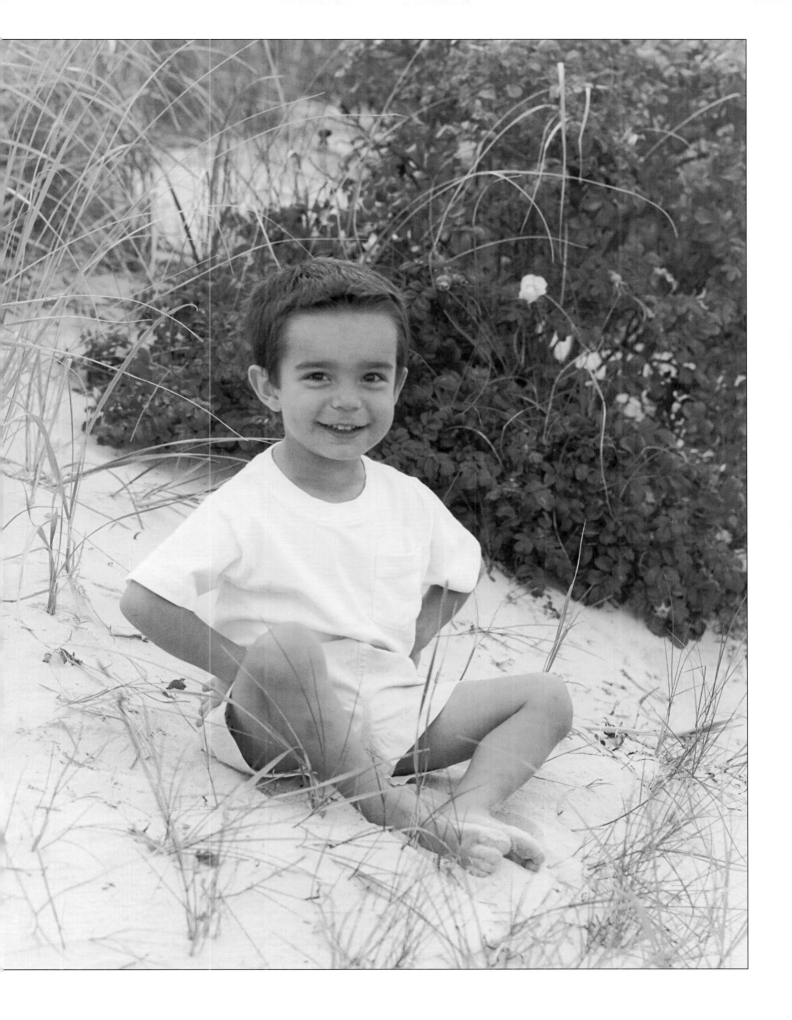

"Parents are not to look at the children or fuss with them."

Photographing Family Groups

Before I begin photographing a family group, I tell them my "rules" up front. Parents are not to look at the children or fuss with them. Then I get the attention of the little ones with animated mouth noises. Usually one parent ends up looking at the children to see how they are responding to me. I quickly say, "Very bad mommy. She's looking at Sally and not at the camera!" Of course that makes everyone laugh and brings mom's face right back to me.

If a child looks hesitant or very serious, I might say, "Tommy looks a little crabby. Are you having a bad boy day?" Again, everyone laughs and Tommy usually lightens up. I always say "boy" or "girl" when I am speaking directly to a child because my emphasis on their being a boy or a girl makes them feel special. It also makes the adults laugh.

The minute I stop talking, I lose the attention of the children, especially little ones. Therefore, I talk constantly. About anything. Even when I'm changing my roll of film. Sometimes I'll get everyone to sing the ABCs or I'll ask little ones if they know a joke they could tell.

If a teenager is being sulky, I threaten to keep putting more film in the camera until I get what I want. If that doesn't work, I threaten to have all their friends from school come and watch. Clothing is often a problem with teenagers, and I tell the parents to leave it to me. If a teenage son insists on wearing a baseball hat, I start the session with the hat on. Then I walk over, take off the hat, and just keep right on photographing. If the mother had

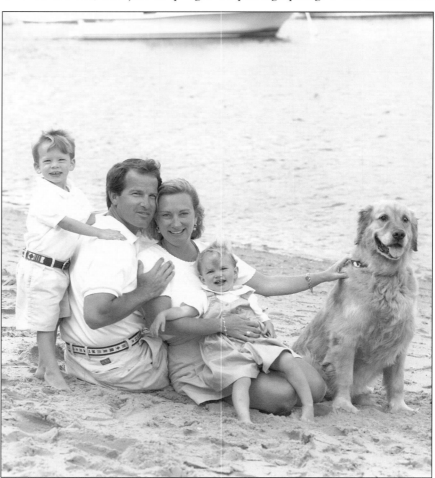

4-10: Position the parents close together, add the dog, then add the children from oldest to youngest. Photo by Helen T. Boursier.

4-11 (right): Here's an example of a family portrait of just the blood relatives. With a big family reunion, be sure to get a picture of just the "blood." Photo by Helen T. Boursier.

4-12 (below): The extended family group is the most challenging because you must deal with so many people, so many personalities, ages, short attention spans, and so on. Photo by Helen T. Boursier.

4-13: After positioning the parents in the center, I positioned the kids oldest to the youngest. I try to place the oldest child in a more dominant position, and the youngest in a "younger" position. Photo by Helen T. Boursier.

"Next, I position the kids, oldest to youngest."

done that, there would be a fight. Since I'm an authority figure (and a stranger), the teenager is too stunned to say anything. Know what the mother is looking for, and make sure she gets it.

After I photograph the entire group of a family reunion session, I tell everyone the next grouping will be just the "blood" and everyone else gets to take a short break. This makes people laugh and eliminates the tension of asking the in-laws to step out of the image for a few minutes. I have had many mothers tell me later that they appreciated my taking a few poses with just the immediate family.

Another trick you might use is to make sure everyone touches someone. I usually start a family grouping by posing the parents in the middle on the ground. I physically sit exactly where I want the man to sit, and when he is settled, I sit down close to the man to show his wife where she should be.

Next, I position the kids, oldest to youngest. I tell them we're building a "people puzzle," and the puzzle fits better when biggest pieces go first. It is particularly helpful to place toddlers last since they get bored quickly.

Regardless of the age of the children, I position the oldest in the more dominant (maybe standing) position and the youngest in a "younger" position (maybe sitting). For example, on the photograph of my in-laws, the youngest two children are actually the tallest. I put my tall husband in the front row so his shorter, but older, brother would have a dominant position. It is important to respect the hierarchy within a family, regardless of whether the children are toddlers or grown adults.

Begin a family reunion session with the largest grouping to be sure everyone is at their freshest. Do not begin photographing until everyone has arrived. The larger the group, the more likely the best images will come in the first few frames. The longer the session, the harder it is to get everyone looking their best all at the same time.

After photographing the desired family groupings, photograph the children as a group and then the children individually. It is already such a production to get everyone together for the photo shoot, so get every possible combination. It's better to over-shoot than under-shoot and have clients regret that some shots were neglected.

Chapter Five

Lighting Techniques for Business Portraits

The "head shot" is the most basic studio portrait lighting technique, and knowing the correct way to pose and light a head-and-shoulders subject should be the foundation of your studio portrait skills. Most studios offer business portraits, which include a basic sitting fee, a few quick poses, and one or two 4x5 glossies.

Roy Madearis Equipment List

Camera: RB67

Favorite Lenses: 127m and 180m

Main Light: Photogenic 16" Parabolic

Fill Light: Norman P800D watt second power box with two Norman LH2000 light heads bounced off the back wall

Background light: Photogenic 25 watt second

Film: Kodak T-max 100

Paper: Kodak F surface RC

Madearis uses an 800 watt Norman as a fixed fill light bolted to the wall and bounced off the back wall. His fixed hair light is bounced off the ceiling to give soft overall light on the shoulders and hair. The background light gives a hint of light. He uses a 2:1 lighting ratio because, he explains, "You don't want a lot of contrast for a reproduction image. The 1:2 has a bit more contrast but is too harsh."

Madearis feels that the color of the background is critical. The reddish brown "hickory" color gives the black & white image a beautiful tonal value for the background. Stark white looks too harsh on a black & white shot, and black makes everything blend in unless you have a really good printer.

When it comes to photographing business head shots, Madearis takes a unisex approach. He photographs from the jacket pocket up for a clean, neat, professional look.

"...the color of the background is critical."

5-1 (top, left): "Hickory" background. Photo by Roy Madearis.

5-2 (top, right): "Stark White" background. Photo by Roy Madearis.

5-3 (left): "Black" background. Photo by Roy Madearis.

If the subject is wearing a company lapel pin, he turns the body so the pin is on the side closer to the camera. He poses the body at a 45 degree angle to the camera, with the eyes looking right into the lens. "Eye contact is very important in a brochure," Madearis says.

Always ask what the subject is going to use the photographs for. Business card photos, for example, are typically placed in the upper left corner of the card. Therefore, the subject needs to look into the card — and be photographed facing left.

Once Madearis has determined the end use of the photographs, he takes two exposures of the subject. He uses Polaroid 665 positive/negative film. He pulls the instant black & white Polaroid proof and places the negative in the developer tank. The subject can then quickly choose their favorite image.

"Generally, we throw away the number two negative so we never have the chance to mix it up later. If the client requests that we save both, we will," he says. "But usually there is no reason to. Ninety-nine percent of the time we can get the image in two shots," he says.

Madearis also offers a "complete business session" shot on color film. He has a Mamiya RB67 which takes ten exposures on a roll of 120 film, but he shoots only nine exposures since that is what fits on an 8x10 contact sheet. Then he uses the Kodak electronic Prism® system to instantly show the images to the client.

He generally takes two head-and-shoulders facing left, two facing right, and six three-quarter poses. He instructs the client to file the contact sheet for future reference.

5-4 (top, left): Madearis says the correct exposure is the reading from the light meter, regardless of the client's skin tone. "If it looks like you should have opened up a stop for more light, that means you just underexposed it in the first place." Photo by Roy Madearis.

5-5 (top, right): Photographer's business portrait. Photo by the Madearis Studio.

Every black & white glossy that leaves Madearis Studio is printed with the same head size. That way, if an employee comes in this month, next month, or next year, all the head sizes will match.

Madearis says the correct exposure is the reading from the light meter, regardless of the client's skin tone. It is often said you should open up a half or full stop depending on the skin color, but Madearis maintains that a correct exposure is a correct exposure. "If it looks like you should have opened up a stop (for more light), that means you just underexposed it in the first place."

Madearis stresses the importance of printing process quality to ensure the photograph has the best possible reproduction. He instructs customers to request 120 dot screen halftone at the printer. Each dot represents a spot of ink on the page. The fewer the dots, the more mottled the photograph looks. Since business brochures are printed on high quality paper, customers can take advantage of the higher dot screens for a better quality finished piece.

Michael L. Boursier Equipment List

Camera: RB67 or Calumet 4x5 view camera

Favorite lens: 100mm to 200mm zoom (RB) or 210mm on view camera

Main light: White Lightening 600 watt second with 42" brushed silver umbrella

Fill light: Same/powered down for a 3:1 light ratio

Background light: White Lightening with honeycomb grid

Separation light: White Lightening with diffusion disk

Film: Kodak Verichrome Pan Black & White (100 ASA) or Kodak Tri-X Ortho

Paper: Kodak Polymax II F Surface RC

Boursier Photography has a full-time darkroom technician on staff, so it is easy to offer quick turn-around time for business portraits. We use Kodak Verichrome Pan Black & White 120 film. If we have a series of sessions scheduled back-to-back (i.e. for an insurance company or a hospital), we take five exposures (half the roll of film) per person. For an individual session at the studio, we use the full roll. We process the film the same day and make a contact sheet the following day. The photographer immediately chooses the favorite pose and the darkroom technician prints two 4x5s.

"We process the film the same day..."

We used to send the contact sheet out and have the client choose the pose, but that wasted a lot of time. We have found it easier to quickly print up the best pose as soon as the contact sheet in printed. We will reprint another pose if the client does not like our choice. Clients, however, have rarely switched poses and appreciate the quick turn-around we can provide. The session fee includes the contact sheet and the two prints.

5-6: Boursier business sessions include three poses taken with the subject facing to the right, three facing to the left, and four poses with a variety of expressions and poses. Photo by Michael L. Boursier.

CHAPTER SIX

Studio Portrait Lighting Techniques

"Low maintenance" is my main lighting criteria. My list of equipment supports this philosophy.

Helen T. Boursier Equipment List

Camera: RB67

Favorite lens: 100mm to 200mm zoom

Main light: White Lightening 600 watt second through a large soft box or starfish

Fill light: Small silver reflector

Background light: White Lightening with a honeycomb grid powered down to 25 watt seconds

Separation light: White Lightening through a diffusion disk

Film: Kodak Verichrome Pan Black & White (100 ASA)

Paper: Kodak Polymax II N Surface RC

My equipment list includes a Mamiya RB67 with a 100m to 200mm zoom lens on a studio tripod that I can easily roll around the room. A fixed hair light above the dark painted canvas shoots through a hard plastic diffusion disk. To show the detail in hair without making it glow, I set the hair light more as a separation light. When working against this dark background, I also use a 600 watt White Lightening with a honeycomb grid.

I prefer a starfish-type soft box because I like round catch lights in the eyes, but I can easily shoot with a rectangular version and use spotting dye later to adjust the catch lights. I generally place the main light to the left of the camera, close to the subject. I use a small silver reflector on the opposite side and move it until I like how it softens the shadows on the subject's face. If you are working in a small space, paint your walls white. They serve as soft "reflectors" and soften the edges of the shadows.

6-1 (opposite page): One light source creates a "catch light" in each eye for a natural look. The reflector gently fills in the shadow side, and the overhead light adds highlights to the hair without making it glow. Photo by Helen T. Boursier.

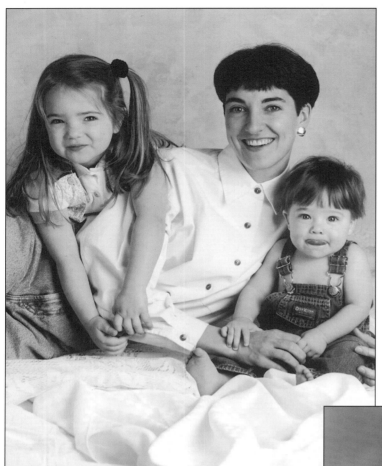

6-2 (left): You don't need a lot of expensive canvas backdrops. I created my own with leftover latex paint and sponges on the reception room wall. The lace tablecloth on top of the muslin covers the floor. Photo by Helen T. Boursier.

6-3 (below): By adding light to the background used in photo 6-1, page 51, you can create a medium key to balance the white first communion outfit. Photo by Helen T. Boursier.

6-4 (right): "Too Many Sisters" was taken with a soft box for the main light, a reflector fill light, a fixed overhead separation light and a background light in front of the painted canvas backdrop. Photo by Helen T. Boursier.

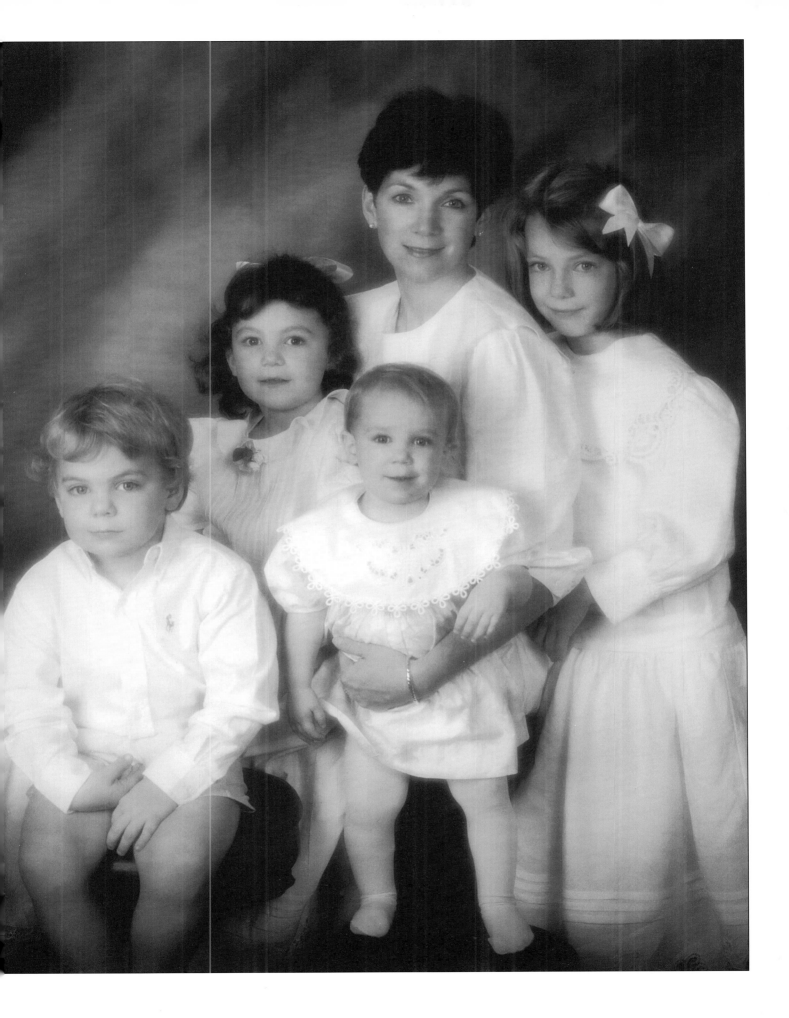

6-5: The classic painted canvas is an elegant backdrop for a timeless portrait. Photo by Helen T. Boursier.

When photographing individual adults, I keep the main light exposure to $f/8.5$, and when working with small children or small groups, I bump it up to $f/11$. I keep the shutter speed faster (250th or 125th) when I'm photographing restless children to make sure the images are tack sharp, but I'll go for a slower shutter speed (60th or 30th) whenever possible to take advantage of the soft fill light available from my two side windows.

John Ouellette Equipment List

Cameras: Mamiya RB67, Burke and James 5x7 view camera, Eastman 2-D 8x10 view camera

Favorite lenses: 250mm for the RB; 14¾" Paragon Anastigmat for the view cameras

Main light: Photogenic Studiomaster II with 16" Parabolic, diffuser and barn doors metered $f/11$

Fill light: Form fill Apollo Light Modifier 22" metered to $f/8$

Over all fill light: Photogenic Studiomaster Umbrella unit at $f/8$

Background light: Photogenic Flashmaster metered $f/8$

Reflector: 2'x3' Larson

Film: Kodak T-Max (100 ASA and 400 ASA)

Paper: Forte Elegance Polywarmtone Fiber Base, glossy and semi-matte

Ouellette does classical lighting for his signature look in bust portraiture. He also uses all electronic flash. Ouellette generally uses five lights, including a hair light, a separation or background light, a parabolic as a sculpturing or key light, and an Apollo light modifier on a Westcott for his main light. He uses a bank fill light (12x5) behind the camera. Three lights spaced 3 to 4 feet apart bounce into a white reflective material and back out to the subject.

His lighting variables depend on the subject matter. For a gentleman, he might add kicker lights to each side of the face for highlights on the hair or face. He might aim a honeycomb grid toward the face or aim a barn door snoot toward the hair.

"...classical lighting for his signature look..."

6-6: The object here is to create strong modeling on the face. Photo by John Ouellette.

6-7: *Classic lighting for a signature look. Photo, entitled "Catherine at 16," by John E. Ouellette.*

Paul Bobkowski Equipment List

Camera: Hasselblad 500cm and Nikon F3

Favorite Lenses: 40mm and 150mm for the Hasselblad and 16mm and 85mm for the Nikon

Main lights: Arri 650 and 300 watt second hot lights

Fill light: Sylvania Sun Gun 600 watt seconds bounced off ceiling

Film: Kodak Tri-X rated at ASA 320

Paper: Ilford Multifiber matte surface and Agfa Portriga fiber papers; Kodak Kodabrome individually graded RC papers

Paul Bobkowski varies his lighting for each situation. He uses two Arri lighting units: 650 watts and 300 watts. "They're like the Mole Richardson lights that have been the industry standard for movie lighting since the 1920s — quartz hot lights that can be focused." He also adjusts the light ratio depending on how he wants the finished portrait to look. "I'll put the 650 on the subject and see how it looks. It might be contrasty, but often I'll leave it."

He might incorporate the Sylvania Sun Gun, a 600 watt bulb light, balanced for daylight and hand-held or placed on a light stand. He might bounce it off the ceiling at camera angles following the angle of the subject's nose if he wants a lower light ratio. For traditional short lighting, he bounces the Sun Gun straight up into the ceiling above the camera. The light is hung on a light stand about 1½ feet below the ceiling, creating a pool of bright light about 3' in diameter. This adds overall soft light and slightly reduces the contrast from the main light. Using only the bounced light from the ceiling creates a light similar to flat daylight. For Bobkowski, the key to studio lighting is to look through the camera and light the subject to suit your objective.

6-8: Paul Bobkowski used soft lighting and Kodak Tri-X film to create this award-winning image. Photo by Paul Bobkowski.

Dean Collins Equipment List

Camera: Hasselblad and Sinar P-2 view camera

Favorite lens: 250mm *f*/4 lens; 250mm and 90mm for view camera

Main light: Large flats positioned just out of camera view

Hair light: Silver reflector to bounce main light back to hair

Film: Kodak T-Max 100 (rates at ASA 64 and processes it 70% normal time)

Paper: Ilford multi-fiber RC F

6-9: With a dark-skinned person, the object is to reduce shadow and increase shine. Photo by Dean Collins.

When commercial photographer Dean Collins began his career in the late 1970s, there was no special information on how to photograph black subjects. "Many of the posing and lighting books on portrait photography talk about highlight and shadow."

"As a commercial photographer, I photograph black subjects all the time — black cars, black leather, black people. None of the portrait books addressed how to photograph black subjects, so I created the concept of three-dimensional form."

"Basically, with light subjects, you work with shadow. With dark subjects, you work with specular highlights," he explains, "On a light-skinned person, photographers add shadow to create depth — reducing specular highlights like shine. With a dark-skinned person, photographers need to reduce shadow and increase specular highlights."

He emphasizes that the actual exposures are the same for both subjects. "You don't open up the lens to a wider f-stop for black subjects and you don't shut down a stop for white subjects. If you did either, you would change the true tonality," Collins says, adding, "If you changed the base exposure, what would you do with an image that had both black and white subjects?"

The object is not to change the way you photograph, but to change your way of thinking. For white subjects, think about adding shadows to create depth, and with black subjects, think about adding shine (specular highlights).

"My job as a photographer is to record true skin tones and then control the shadows and the specular highlights to create a feeling of depth. If you're going to draw on a white piece of paper, you don't pick up a white pencil. Nor would you pick up a black pencil to write on black paper," Collins explains.

He suggests powdering down white people to reduce shine, and adding oils to the faces of black clients to increase shine and pick up highlights. Also, increase the size of the light source for black subjects.

Whether you use five lights or one, the keys to successful studio lighting are simple: Know your equipment and know your shooting space.

"With dark subjects, you work with specular highlights."

CHAPTER SEVEN

Window Lighting Techniques

Using the soft light from a window to naturally light a subject is as old as photography itself. In the old days, photography studios depended on a building with windows on the north side. Photographers controlled the amount of light with thick black drapes.

Subjects were often clamped in place to keep movement to a minimum during the long exposures required. Today's faster films and variable lighting

7-1: You don't need to show the window. The boy is facing a bank of windows which provide soft "broad light." The light naturally falls off in the background. Photo by Helen T. Boursier.

7-2 (opposite page, top): This light "high key" image was taken with Kodak Tri-X film rated at ASA 320. The exposure was f/5.6 at 15th, and a small silver reflector served as the only fill light on the right side. (Nikon 1 soft focus filter diffusion). Photo by Helen T. Boursier.

7-3 (opposite page, bottom): I positioned the kids with the cake so the row of windows behind the camera would give an overall soft illumination. The side "kicker" light on the boy's face is from the light reflecting off the water on the back side of the house through the doors to the right. Photo by Helen T. Boursier.

7-4: *We timed this photo session to take advantage of all the window light in this contemporary home. With so many windows all around, we chose mid-day when the sun was actually over the house so there would be no strong directional lighting coming from any one direction. Photo by Helen T. Boursier.*

"There are many variables to consider in making your work unique."

equipment allow photographers to create "available light" window portraits with a much more relaxed look.

There are many variables to consider in making your work unique. The first is whether to use some source of "fill" light, so called because the reflector, strobe, or hot light gently "fills" in the shadows for softer overall lighting on the subject's face. A second variable is whether to print for the highlight side or the shadow side of the face. And third, whether to print the finished image as a light "high key" or a dark "low key." Once again, the "correct" combination of variables depends on the personal tastes of you and your client.

Richard Barnes Equipment List

Camera: Mamiya RB67

Favorite lens: 180mm

Main light: Photogenic Powerlight 600

Fill light: Photogenic Powerlight 600

Background light: Photogenic Powerlight 600

Film: Kodak Tri-X, Kodak Plus-X Pan, Kodak T-Max 100 and 400 ASA

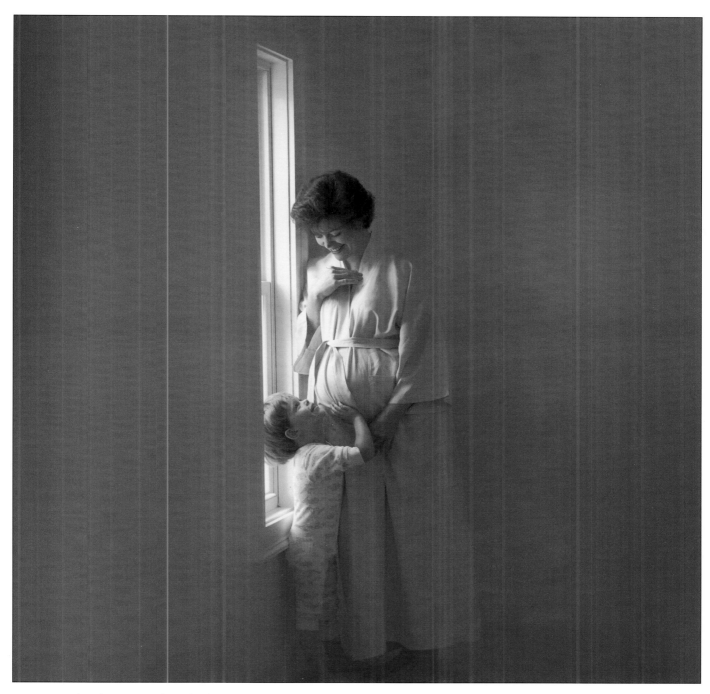

For Richard Barnes, the ideal window lighting situation requires an overall softness along with some light direction, but without sunlight actually streaming in the window. In the studio he uses a 4'x6' piece of white foam core to create an overall softness that complements the softness of the main light coming through the window. He does not use a silver reflector because that mixes light. He says the silver is too harsh, too bright and changes the quality of the image.

Barnes might use a parabolic hot light to add fill light to the top of the hair, shoulders and the shadow side of the face. He bounces it off the ceiling behind the subject. Barnes uses hot lights and not electronic flash for the fill

7-5: The stronger highlight to shadow ratio adds impact to this image. Photo by Richard Barnes.

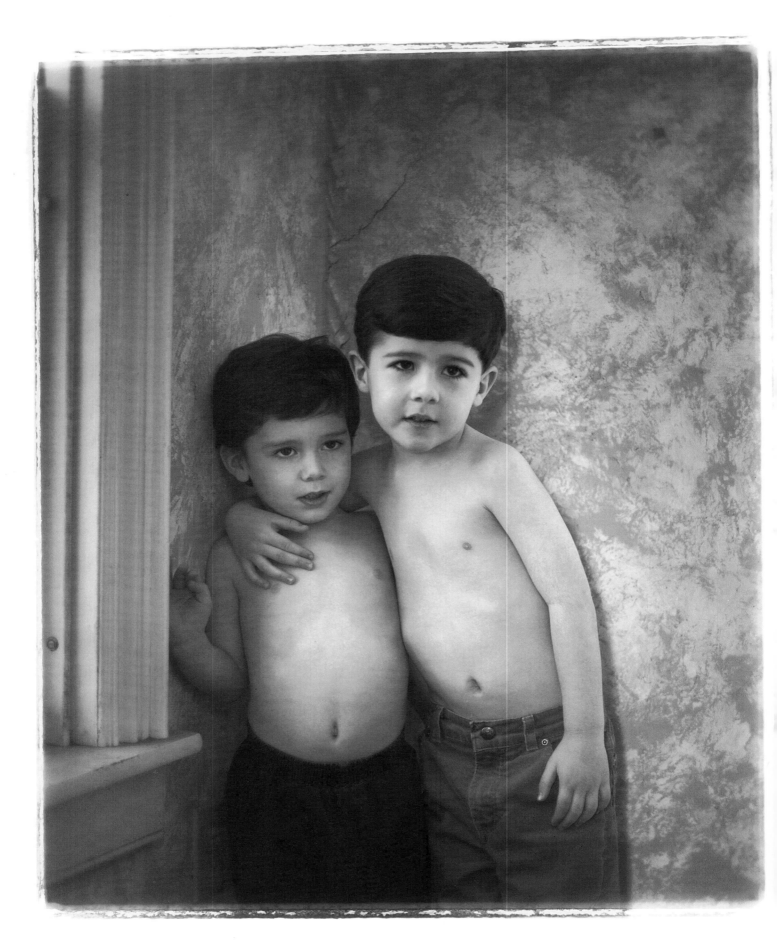

because then he knows exactly what the fill light will look like. Keep the image looking natural. "If you add too many lights, ask yourself why you're doing a 'natural' window light shot in the first place. You may as well just build a fake window light set."

He takes the exposure reading based on whether the subject is facing the window or the camera. If someone is looking out the window, he takes the exposure reading at the face, aiming the meter out the window toward the main light source. The lighting ratio will be strong, and the emphasis will be on the light on the subject's face.

When the subject is looking at the camera, he takes the meter reading from the highlight side of the face. Then he moves the white reflector in close, so the lighting ratio isn't as great. "It's important to have light in both eyes, and not just in the one closest to the window. I meter the main light with a light meter and visually do the rest," he says, adding, "If you're not sure, then take a light meter reading on the shadow side, the background, and the hair." His highlight-to-shadow ratio for a high-key bright look has only one stop difference from the highlight side to the shadow.

For a low-key portrait with the subject looking out the window, he might have 1½ to 2 stops difference, depending on the mood he wants to create.

"The two floor-to-ceiling windows at our studio came with the building, and they face west! Because of this, I schedule my mother/child and children's portrait sessions during the morning when the light is non-directional and soft."

"If I'm going to use window light during a session, I position the camera, props and reflector before the client arrives. I do the window light poses at the beginning of my session while the children are still a little mellow. I prefer to work at $f/8$ or $f/5.6$ with a shutter speed no slower than 30th for most children or 15th for the very mellow. Any slower than that risks blurring the image from the child's movement. Then I power up the strobes, kick up the shutter speed to 250th and move on to my other backgrounds."

"...the emphasis will be on the light on the subject's face."

7-6: (left) Available light from the windows is the main light with a white reflector just off camera to the right. The photographer doesn't want too much contrast so he uses white foam core for the "fill" light. Photo by Richard Barnes.

CHAPTER EIGHT

Available Light Outdoors

Using available light outdoors is, of course, the ideal for photographers. Instead of fiddling with equipment, the artist can concentrate on the subjects. Timing for the best quality of light varies depending on location, but you will almost certainly be getting up early and working late.

Many photographers call the ideal light just after dawn and shortly before dusk "sweet light." Some professional photographers earn a living by photographing only at the beginning and end of each day.

Timing is critical for open lighting situations like a beach or a field, and the two choices are dawn and dusk. A photographer friend routinely does a sunrise session every morning all summer long. She's at the beach with the family as the sun rises over the horizon. Her clients typically have small children. Not only are they used to getting up at 5a.m., but the children would fall apart if they had to stay up for an 8p.m. sunset shoot.

Prime Time Light

To make the most of limited prime time light, I generally schedule two sessions at a sheltered harbor beach followed by two at a nearby open light beach. I tell clients they need to arrive on time, the sun won't wait. I also tell them I have someone scheduled right before and right after them and that I always run on time — to the minute. These strategies curb client lateness.

Weather Conditions

There is very little you can do about wind. Logically, people realize it is windy at the beach or in the middle of a field of wildflowers. But emotionally, they want their hair to look studio perfect for their portrait. Tell your clients to expect wind. Hair spray will help a little when there is a light breeze, and tucking down low behind a dune will cut some of the gusts on a breezy day. However, neither of these tricks will prevent hair from blowing some of the time.

You can spend your entire outdoor shooting season hanging on the words of the weather forecaster, but there is not a lot you can do about the weather. The only way to survive a string of bad weather as an environmental portrait photographer is to get on the offense with your clients. I give an approximate time that I expect to do the photography session, ideally just before sunset.

"Timing is critical for open lighting situations…"

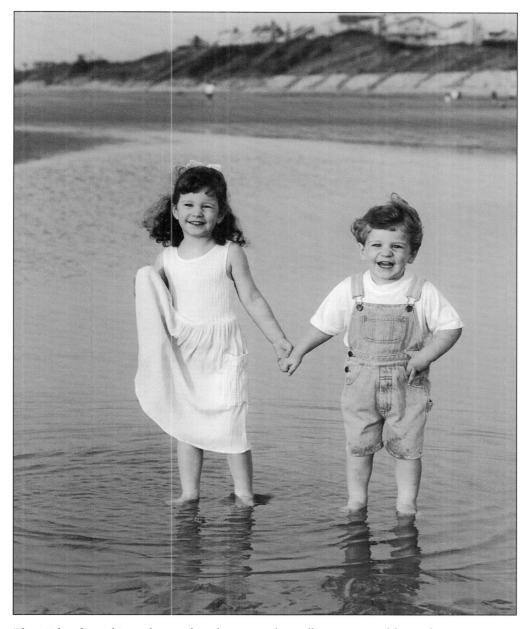

8-1: This photo was taken during the prime time "sweet light" just before sunset. Photo by Helen T. Boursier.

Then I let the subjects know that they must be willing to scramble to the beach as much as two full hours before the projected session time.

The sessions I am able to shoot on chancy weather days are the ones where people take me seriously about "scrambling" to get to the beach ahead of the rain or fog. With the first indication of fog moving in, I quickly call my clients and hustle them down to the beach. The ones who are at work until the last minute (or golfing or boating) end up rescheduling.

Working in Less-than-Perfect Light

If you photograph at dawn or dusk, you'll be working in the best light of the day. Since those aren't always ideal times for clients, you will often photograph in less-than-perfect light. It is common to have to deal with blotchy light from working under shade trees mid-morning to mid-afternoon or photographing at a beach or field when it is too bright. The keys to working in

"It is common to have to deal with blotchy light..."

8-2 (left): The subject is in the bright light of afternoon during a Cape Cod spring day when the leaves are not yet out on the trees to diffuse the light. Photo by Helen T. Boursier.

8-3 (below): To make most of the limited prime time light, I generally schedule two sessions at a sheltered harbor type beach, such as the one pictured here, followed by two at a nearby open light beach. I let my clients know it is important for them to arrive on time as the sun won't wait. By letting my clients know this in advance, I rarely have people arrive late. Photo by Helen T. Boursier.

8-4 (right): The sun is setting below the trees behind the subject, and an open batch of sky in front of the little girl provides soft light. I used only available light, and took the exposure reading from the shadow side of her face. Photo by Helen T. Boursier.

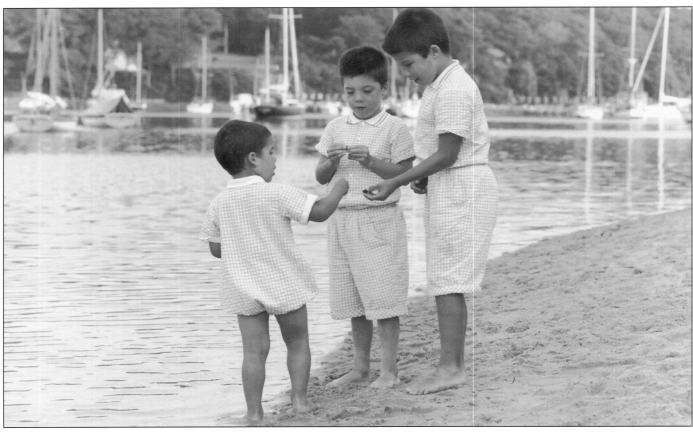

8-5: Tuck your subjects down low to take advantage of shade at the edge of an environmental element like a dune or a hedge. Take your exposure reading off the shadow side of the faces. Photo by Helen T. Boursier.

less-than-perfect light are the relation of the subject to the light and a proper exposure reading. When working in blotchy light, I try to find a shadow area large enough for the subjects to pose in. Ideally, I want the background to have as few light speckles as possible. The more light bouncing around in the background, the more your eye will be distracted from the subject. In most open light situations, I position the subjects with the sun behind them diagonally to the left or to the right.

With bright light at the beach, look for shade. While clients think a bright sunny day is the ultimate situation for their family portrait, no one wants to squint. Tuck a small group down in the sand in the shade of a dune. This

8-6: _Beautiful light quality is as convenient as the client's back yard. This image was taken just after the sun set behind the trees at the edge of the yard. The only way we could get the toddler to sit still enough for the 1/30th of a second exposure was to put him on top of the slide. The instant he sat down — click. Photo by Helen T. Boursier._

trick will not work with large groups, however, so I schedule their sessions shortly before sunset.

Another way to deal with bright light at a beach or field is to position the subjects right out in the open with the sun to their backs. This creates a very strong highlight-to-shadow lighting ratio that looks energetic.

In all of these tough lighting situations, most photographers would break out the reflectors, bare bulb, or strobes. I never use anything but my light meter. I don't like fake-looking portraits that create unnatural lighting, and I would rather fiddle with the people than with the equipment.

Jay Goldsmith Equipment List

Camera: RB67

Favorite lens: 180mm lens; 90mm lens

Main light: Available light outdoors/ Norman P800D for studio portraits

Fill light: Available light outdoors/reflector indoors

Film: Ilford XP2

Paper: Agfa Portriga Rapid III toned, Ilford Multigrade III and Luminous Charcoal

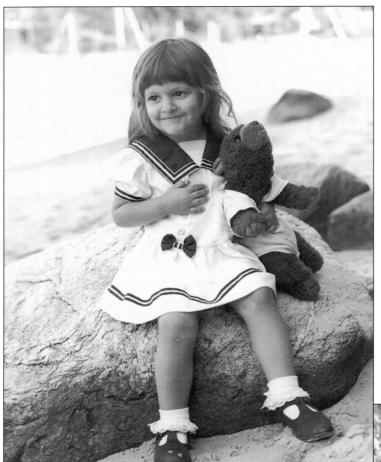

8-7 (left): Working at the edge of shade to get quality light on the subject does not guarantee quality light in the background. Instead of a medium gray tone for the water, it has a brighter high key look. Photo by Helen T. Boursier.

8-8 (below): You can soften harsh lighting on the face by placing the subject so the light is coming from behind. Expose for the shadow side of the face. The backlighting creates a brighter, almost high key effect in an otherwise low key setting. Photo by Helen T. Boursier.

8-9 (opposite page, top): The weather forecast predicted rain moving in. We started the session at 5pm as soon as the clouds moved in on an August afternoon when sunset is around 7:45pm. Photo by Helen T. Boursier.

8-10 (opposite page, bottom): Thick clouds had moved in when we rounded up the cousins for one last photograph. I used Kodak Tri-X film rated at ASA 325 with an exposure of 60th at f/8. Photo by Helen T. Boursier.

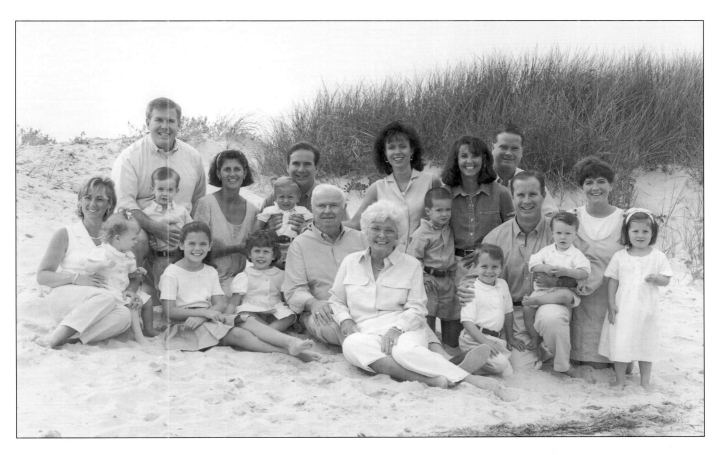

Photographer Jay Goldsmith put it this way: "I never use flash outdoors either for color or for black & white because there is too much other stuff to worry about. Plus, as soon as you add flash, the image immediately looks artificial, and people see that. It looks like a background that's been pulled down at a department store."

Using a Light Meter

With no flash unit, you absolutely must use your light meter correctly. I physically walk up to the subject and take an incident light reading off the shadow side of the face. It is not enough to stick out your arm from the camera position, put the back of the meter toward the client, and punch the button on the meter. The dome records all the light spilling onto it from the top and sides, so the exposure will be slightly off.

Another method photographers use is to replace the dome with the disk and take the reading from the camera position. Others cup their hands over the dome to simulate close proximity to the client's face. Underexposed faces and "raccoon eyes" are the result.

I prefer to use f-stops of $f/8.5$ or $f/11$ for family groups so everyone is in focus. I also try to keep the shutter speed above 60th for large groups or children. Again, sharpness is the goal.

Ideal Lighting Conditions

You can find lots of pretty light well after sunrise and long before sunset if you know what you're looking for. Try to work near the edge of something — an office building, a hill, a grove of trees or a house. Heavy shade is less than perfect light, but heavy shade with soft fill light bouncing in from a nearby white building or a bright open patch of sky overhead can give just the extra light you need. For example, Goldsmith exposed for the shaded light at the edge of the trees for the mother/child portrait. The open sky behind the subjects provided the accent light (see photo 8-11).

There are jobs — like weddings and family reunions — where you just can't depend on available light. You need to pass up those jobs, or master a "fill flash" style that works for you. The next chapter explains how.

"...master a fill flash style that works for you."

8-11: (left) The photographer works exclusively with available light to create the most believable images. Photo by Jay Goldsmith.

Foolproof Fill Flash

"Fill flash" is one of the most abused techniques in portrait and wedding photography. The object of fill flash is to is to add as little light as possible so you illuminate the subject without completely wiping out the effect of the existing ambient light. Also, if you over-flash, you create very contrasty "flat" light with an unflattering shadow off to one side. The key is to balance the "fill" light with the available light.

9-1: This photo is little more than a snapshot. The on-camera flash is too hard. The image is too contrasty and there is no modeling to the face. The shadow in the background isn't very attractive either. Photo by U.S. Navy.

9-2: Barnes says the key word is fill. Don't over-flash the Lumedyne, which would create a main light and, from the camera angle, flat light. You would defeat the whole purpose of natural light. Photo, entitled "Welcome Home," by Richard Barnes.

Reflectors and Fill Light

Richard Barnes prefers using light that he does not have to manipulate. His first choice is to use a 42" brushed gold reflector to add modeling on the face. If the light is too harsh, he uses a Lumedyne lighting unit and a bare bulb flash fill. He takes the reflector off and faces the flash head straight toward the sky. The fill light is on a light stand 8 to 10 feet above and behind the camera. You could also use a bare bulb in front of the camera, but you would need a piece of cardboard on the back of the light so it doesn't give lens flare.

Barnes wants 1½ *f*-stops between the shadow and the highlight. If it is much greater than that, he'll use the fill to balance the ratio. Too much "fill" creates a flat main light. He photographs late in the day when the sun is low on the horizon. The main light is a patch of open sky at a 45° angle to the subject's face. The "fill flash" adds highlights to the face and prevents the eyes from looking too dark.

"Too much fill creates a flat main light."

Cheryl Richards Equipment List

Camera: Hasselblad and Canon

Favorite lenses: 50mm (Hasselblad) and 85mm (Canon)

Flash unit: Metz 60 CTY

Film: Kodak T-Max 400 and 3200 ASA

Paper: Agfa Portriga and Ilford Pearl

Wedding photographer Cheryl Richards prefers a through-the-lens (TTL) Metz with a Hasselblad 503CX that is TTL compatible. She simply puts the flash on the TTL setting. The camera takes any ambient light into consideration and then the flash gives either a bit of output or a lot. She says, "I set my flash in the morning and basically never have to do anything with it for my candids the rest of the day."

Richards does change her settings for formal groups to ensure the amount of light is "fill" light and not "main." With the TTL flash style, you set the film ASA to tell the flash what the output should be. She sets her ASA to correlate with the desired flash for the situation.

For example, if she changes the ASA from 400 to 640, the camera thinks it has faster film so the flash unit gives her less light.

9-3: Richards uses the manual flash setting when she does formals to take advantage of the available light of the location. Photo by Cheryl Richards.

If the lighting at the couple's requested location is particularly bad, Richards offers an alternative. "I'll suggest we move to, say, a beautiful porch where the lighting is perfect," she explains. "When I get them in position, I'll do a Polaroid to make sure they like the setting. I'd hate for them to be unhappy after the wedding when they see the proofs. Also, I'll take the bride and groom down to the lighthouse or beach later in the day when the lighting is soft."

Roy Madearis Wedding Equipment List

Camera: Hasselblad 503CW

Favorite lenses: 60mm CF

Flash unit: Metz 45CT4 with Quantum II battery

Film: Kodak Pro 100 and Pro 400 color printed on Black & White paper as needed

Paper: Kodak Ektalure G

Roy Madearis uses a Quantum Flash T-2 strobe with a Turbo battery. It has 19 manual settings and 25 automatic settings on ⅓ increments. He routinely tests all strobe units for accuracy.

"...routinely tests all strobe units for accuracy."

9-5: *Madearis uses a minimal amount of fill light to create an image of the ballerina bride and her daughter in keeping with the reflective mood. Photo by Roy Madearis.*

"...check the computer data on the backs of your wedding proofs"

The question to ask yourself is whether you should trust your light meter or your camera for proper exposure. He suggests photographing three different situations — close up or three-quarter length, full length, and full length large groups — then send the film to the lab. With a 60mm lens on a Hasselblad camera, Madearis makes the test at 6 to 8 feet, at 8 to 10 feet, and again at 15 feet — close-up or three-quarter length.

The lab will tell you if you're a stop over or a stop under. Based on the results, change the dial on your strobe unit. To keep the lens at $f/8$ for optimum results, re-program the strobe head for the $f/8$ reading.

To make sure the camera and lighting gear stays on track, you can regularly check the computer data on the backs of your wedding proofs. When the numbers indicate the exposures are off slightly, re-test your equipment and adjust the strobe head accordingly. Madearis maintains that you can take five strobes, set at the same intensity for the same lighting situation, and come up with five different results. These changes are more noticeable as the strobe gets older.

Madearis checks the proof package every time a job comes in to ensure strobe accuracy. He has learned to automatically bump up the f-stop head reading to $f/5.6$ when backing up 15 feet to do a large scene or group.

CHAPTER TEN

Black & White Wedding Photography

Photographing weddings in black & white has its own unique set of challenges. Brides book the photographer based on style, request some or all images to be done in black & white based on personal tastes, and leave the logistics of lighting the two styles in the hands of the photographer.

Julia Russell Equipment List

Camera: Hasselblad 503cxi and Nikon 8008S

Favorite lens: "Never the one I own. Always the next one I dream of purchasing!"

Flash unit: Metz 60CT4

Fill flash unit: Armatar LR200

Film: Ilford HP5

Paper: Kodak Ektalure fiber base

Julia Russell's business is devoted exclusively to weddings. Brides hire her because they see the romantic element in her work. "I enjoy all things romantic — food, silk dresses, flowers — and people see that in my work."

Her philosophy on weddings is to photograph what is there, do not go and create what does not exist. "I don't go to a wedding with any formula. I don't have a list of only select shots I want to take. I go in with an open mind. That's when I do my best work. Not all brides will give a photographer full reign, however, and will have a list of photographs that they want to be sure are taken."

When a bride and groom ask for black & white photography, Russell asks which images they see in black & white. For example, she has photographed weddings where black & white photographs were used as the first page of each new section in the wedding album — at the bride's home, at the church, formals, and at the reception. The other photographs in between were in color. She recommends that a reason is needed for black

"...photograph what is there, do not go and create what does not exist."

10-1: Take advantage of the various backdrops at the ceremony and reception locations to quickly capture the memories of the day. Photo by Julia Russell.

10-2 (opposite page): Russell likes black & white portraits where the light skims across the subject, setting off the delicate detail of the bridal gown. Photo by Julia Russell.

& white photography to be included in the album, instead of having it mixed in at random. Given the choice of which images she will photograph in color and which she'll take in black & white, Russell looks at both the light quality and the image content. She prefers a higher light ratio for black & white photographs because she likes and wants to get the really black blacks. She also sees light skimming across the subject for her black & white images, and often takes advantage of window lighting.

She also thinks the classic photos should be in black & white because they are more symbolic. The color is more of a reflection of the way things actually are on the wedding day.

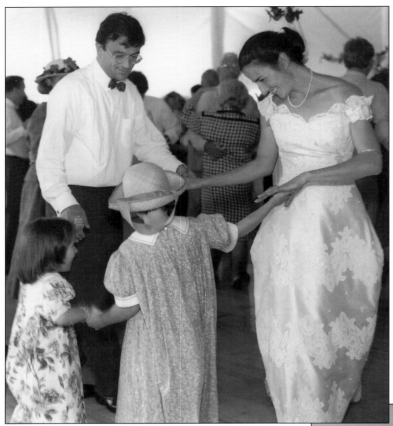

10-3 (left): Richards uses her photojournalistic style to capture the emotions of the wedding day. Photo by Cheryl Richards.

10-4 (below): When Seefer is lighting black & white in the studio, he often uses a bare bulb or mini spot lights that focus. He will use a soft box for fill light. With f/5.6 as his base exposure for his fill light, he might go as high as f/11 for the main light with his mini spots. Photo by Martin A. Seefer.

10-5 (opposite page, top): Another example of how Richards' photojournalistic style captures the wedding day. Photo by Cheryl Richards.

10-6 (opposite page, bottom): Richards' most common requests for black & white are with the posed pictures. Then they generally ask her to simply mix up the candids with some in color and others in black & white. Photo by Cheryl Richards.

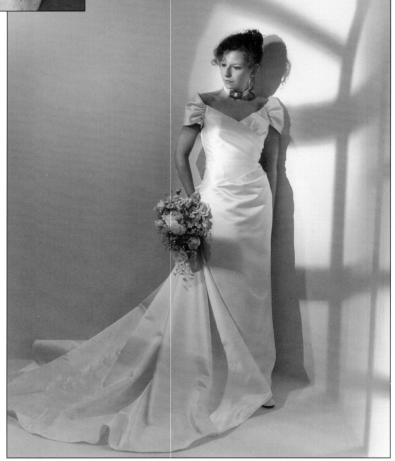

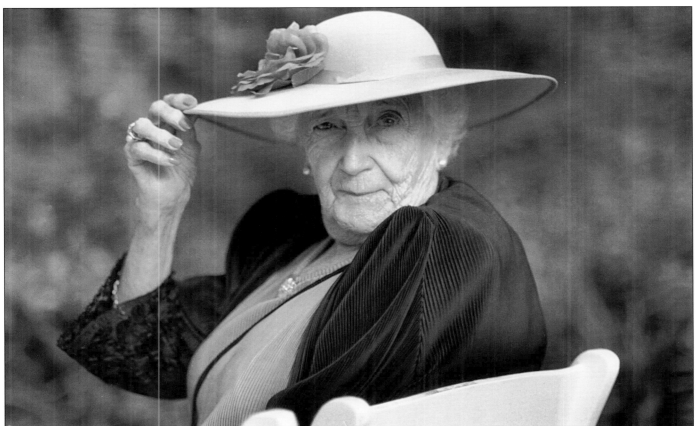

Horace Holmes Equipment List

Camera: Hasselblad 503cx

Favorite lens: 120m

Flash unit: Metz 60CT-4

Fill light: two Photogenic 600 units bounced off a white umbrella and placed at the back of the church

Film: Kodak Pro 400MPC (color — rated at 400 ASA)

Paper: Kodak Panalure Black & White or Kodak color paper printed to look sepia toned

Horace Holmes uses color film to photograph every aspect of weddings. Then he has the lab make black & white photos from the color negatives as requested by the bride. If the bride wants classic black & white with all the gray tones, he has the lab print on Kodak Panalure paper.

"I like to integrate some black & white into the wedding album, but I want to have the capability of making color prints from those same images," Holmes says. "The bride will love whatever black & white images are in her album because it is her wedding and she is going to love everything anyway. However, when relatives see that same photograph in the album, they will ask if they can get that black & white in color."

10-7: Two Photogenic 600 lights bounced off white umbrellas and positioned at the rear of the church provide fill light. Holmes sets the lights for an f/8.5 reading across the front of the church. He always works on a tripod, dragging the shutter all the way down to one-quarter second exposures. His goal is to take advantage of all the ambient light to show off all the beauty and texture within the church. Photo by Horace Holmes.

10-8 (above): Holmes never brings a portable painted or canvas background because he believes in using the existing environments at the church and reception halls. The bride typically chooses these locations for a reason, and he does not want to cover them up with studio-looking backdrops. Photo by Horace Holmes.

10-9 (right): Holmes says it is easier to photograph the wedding entirely in color and then have the lab make black & white prints as individually requested by the bride. Photo by Horace Holmes.

Cheryl Richards Wedding Equipment List

Camera: Hasselblad and Canon

Favorite lenses: 50mm (Hasselblad) and 85mm (Canon)

Flash unit: Metz 60 CTY

Film: Kodak T-Max 400 and 3200 ASA

Paper: Agfa Portriga and Ilford Pearl

Cheryl Richards calls her style photojournalistic. She poses a window light shot of the bride at her home just prior to leaving for the ceremony. The rest of her images capture the day as it unfolds.

She does not pose the bride with each of the bridesmaids or the bride pinning the flowers on her dad. If they are ready, she photographs the bride with her parents and the bride with all her bridesmaids. The rest is natural as the day unfolds.

Richards says that half her clients know that they want black & white and the other half are merely curious. Initially, she shows black & white 10x10s matted with a 4" border.

The museum matting gives each image a more artistic look. She then shows two black & white albums and ends the sales visit by showing a color album sample.

10-10: Richards says she does not stage her images. She prefers to capture the day as it unfolds. Photo by Cheryl Richards.

10-11 & 10-12 (opposite page, top and bottom): Richards photographs anything interesting she sees. She's not going to let herself get stressed if the bride isn't ready or if something runs behind schedule. She simply photographs everything that's happening naturally. Photos by Cheryl Richards.

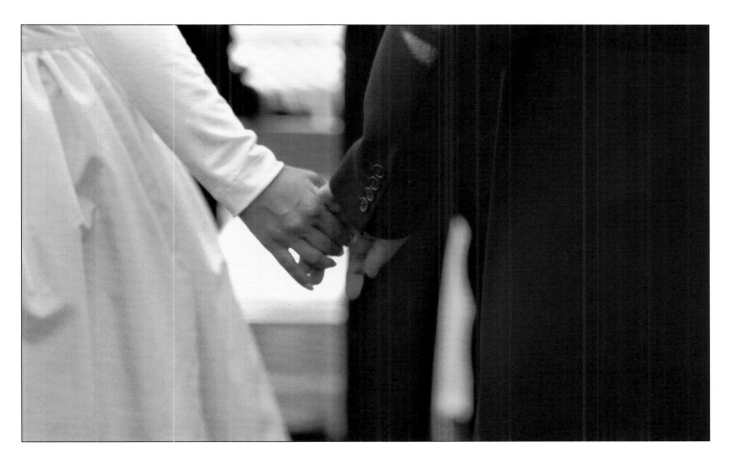

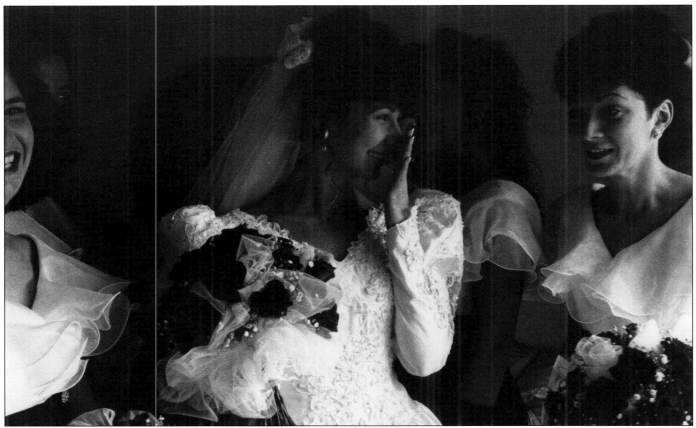

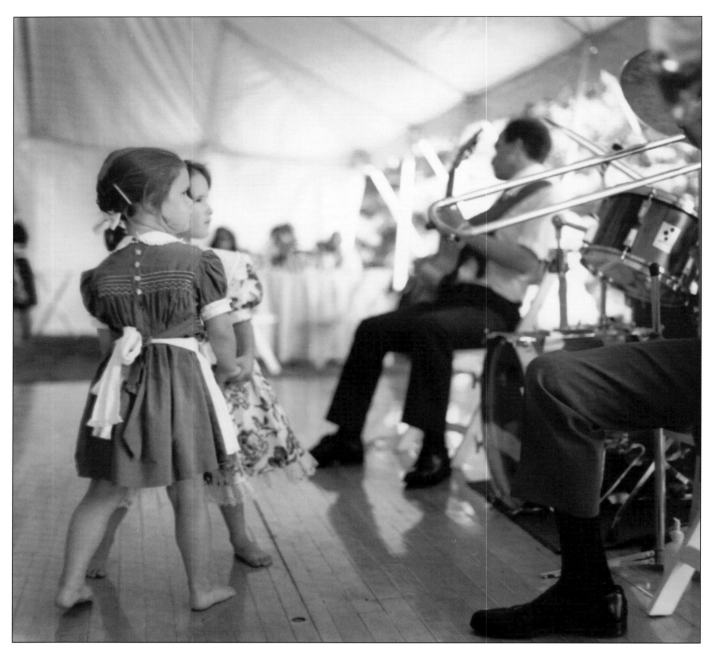

10-13: Richards prices the weddings the same, whether they are all color, black & white, or half and half. Photo by Cheryl Richards.

10-14 (opposite page): Seefer uses a large soft box for his main light and a reflector fill in the shadow side. He takes his time to carefully pose each bride. Photo by Martin A. Seefer.

"After looking at all the black & white work, the color just doesn't have the same timeless quality," she says.

About half her clients go with 100% black & white and the other clients prefer half color and half black & white. "If they say they want all black & white, either for the formals or for the entire wedding, I always do some color. They might regret not having any color when they look back on their wedding ten years from now."

When the bride wants the wedding photographed half in color and half in black & white, Richards decides which film will be shot at which location.

For example, she does everything at the church in all color or all black & white, including the processional, recessional and the ceremony. She does not change films back and forth because it is easy to get confused under the pressure of the ceremony.

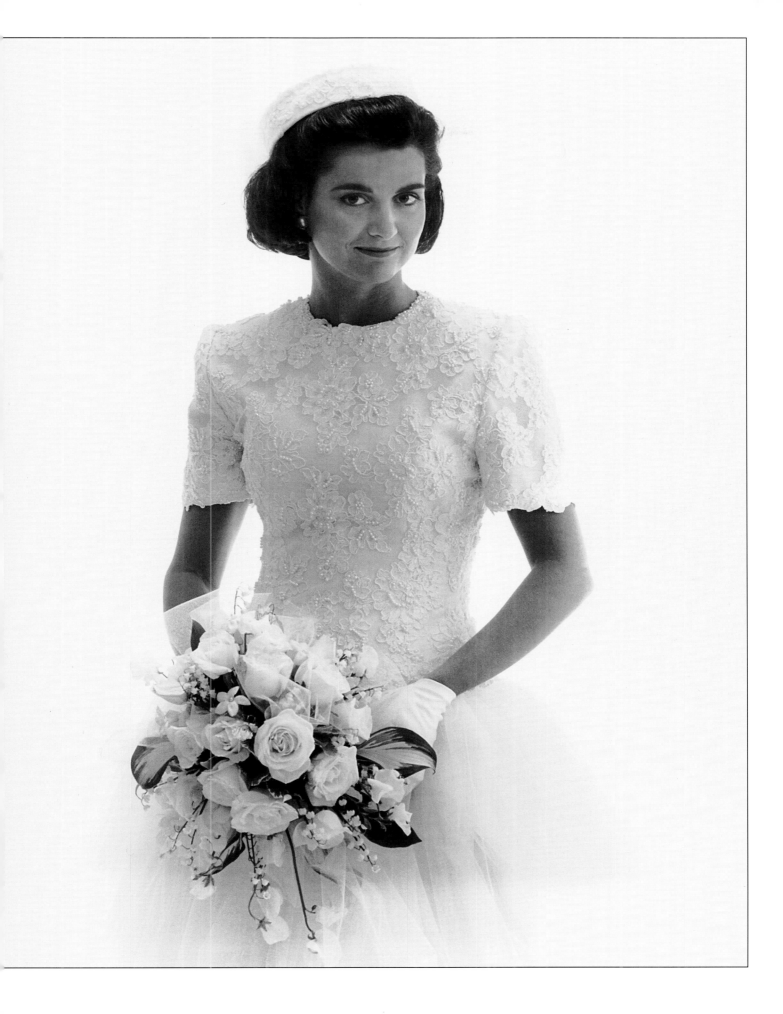

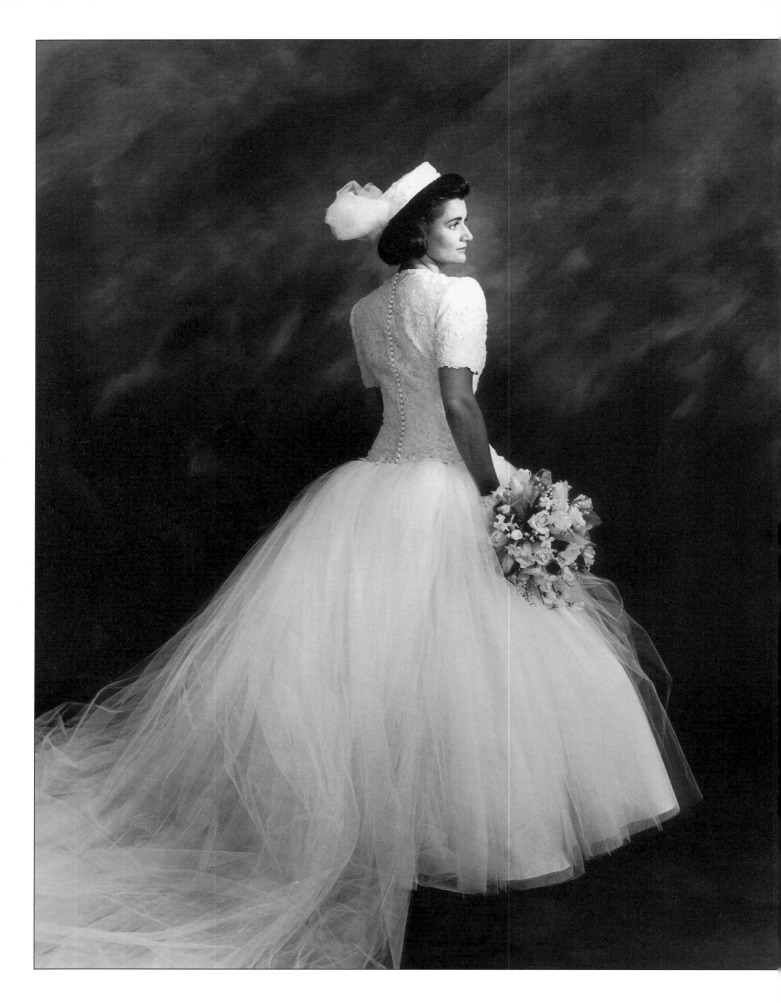

Martin A. Seefer Equipment List:

Camera: Hasselblad cm and Mamiya RZ

Favorite lens: 150mm lens; 180mm lens on RZ

Main light: White Lightening Buff Ultra 1200 through Photoflex 3 soft box

Fill light: White Lightening 1200

Background light: White Lightening 1200

Flash unit: Lumedyne

Reflector: silver Photogenic

Film: Kodak T-Max 100

Paper: Kodak Polymax RC and Agfa Forte fiber

Martin A. Seefer offers black & white in his weddings three different ways. He does all the formals in black & white before the ceremony. Whether he photographs at the bride's home, at the church, or both sides of the wedding party and the families before the ceremony, black & white stops at the ceremony and color begins. His second variation is a dream sequence session of the bride and groom taken at some point during the wedding day. All of the images are black & white and the feeling is romantic. He prints with a sepia tone and adds these images to the last pages of the album. The third option is what Seefer calls "helter-skelter." It is his least preferred method because he uses distinctly different lighting styles. It makes the photographer's job very hectic.

For a color wedding image with a base exposure of 5.6, Seefer will not go above $f/8$ or $f/8.5$ for the main light. (That makes about a 3½:1 ratio.) Seefer prefers to use a 3:1 or 4:1 lighting ratio for color images, but he will increase that to as much as a 6:1 ratio for his black & white work.

Another key difference between color and black & white is the longer exposures for the black & white images. It is not uncommon to have a ½ second exposure for a studio bridal. "The longer exposure allows the incandescent lighting to give a richer tonal range. It gives more of a wrap-around lighting with more form fill. The background comes in better and the shadows aren't so deep," Seefer explains.

"Electronic flash is too broad a light for black & white. I'll always use flash with a soft box and a reflector for color, but that just doesn't give me the results I want for a black & white bridal portrait."

When he's working on location with the hectic pace and the nervousness that goes with the wedding day, he lights most of his black & white work using the same equipment as his color shots. Instead of dragging along the mini spots, he uses a bare bulb for the main light with a soft box for fill, plus an extra "kicker" light to add specular highlights to the side of the face or rim of the nose.

When it comes to weddings, photographers agree that brides want black & white coverage. Whether you choose to offer a little black & white or a lot, your only smart option is to offer at least some.

"It gives more of a wrap-around lighting with more form fill."

10-15: (left) When it comes to style, the number one feeling Seefer wants to project is regal. "The bride, in her gown, should look regal. I expect superb posture for a bridal portrait." Photo by Martin A. Seefer.

CHAPTER ELEVEN

Special Effects with Black & White

Soft focus filters, high speed film, texture screens, creative lighting, Polaroid transfers, and film and/or paper processing manipulation are some of the variables that can completely change the look of your black & white portraits.

You may choose to alter your images dramatically by solarizing the negative or by adding a slight diffusion during the printing. The more radical manipulations included here are often personal projects, and the more conservative alterations are client commissions.

Soft Focus Filters

Black & white photographers have a love-hate relationship with soft focus images. Soft focus filters reduce contrast and "flatten" the image. Since most black & white photographers like their blacks black and their whites white, soft focus is viewed as somewhere the middle. Successful soft focus comes from understanding its strengths and weaknesses.

I use soft focus to soften the feeling of a print and add an element of romance. Soft focus looks nice when the subjects are looking off camera. Avoid strong back-lighting when using a soft focus filter because it creates a glow from the halation. You could also keep the center of the image sharp and use soft focus only around the edges.

An inexpensive way to do this is to use clear fingernail polish on a clear UV filter. You can also use clear vinyl with a hole cut in the center and placed in a vignetter box.

My favorite soft focus for black & white is a Nikon One soft focus filter. I removed the metal ring and put a piece of clear tape for a "tab" on one edge of the glass so I can quickly take it out of my vignetter box.

Experimental Lighting

Paul Bobkowski was brainstorming with a client about a creative shot for a band flier when he took an image of the lead singer (see photo 11-9, on page 100).

"...completely change the look of your black & white portraits."

He wound up a light fixture that had teardrop glass pieces hanging from it. When he released it, the fixture spun around in front of the subject during the one second exposure on Kodak Tri-X film. "I just lucked out. The image looks really fantastic."

Bobkowski also created the image (see photo 11-8, page 100) of the eyelash and the nose as part of a creativity "jam session." He used 3200 Kodak Tmax film rated at 800.

You can change the look of an image simply by creating a more noticeable grain structure or texture. You can either do it in the camera with a high speed black & white film, or in the printing with a texture screen.

11-1: Seefer created this unusual image with a Photogenic mini spot. He had a one second exposure of f/8.5. He allowed the film to develop for fifteen seconds, then removed the backing from the film and exposed the negative to a flash of white light. He washed the negative in warm water and allowed it to dry. The solarized neg was printed normally. Photo by Martin A. Seefer.

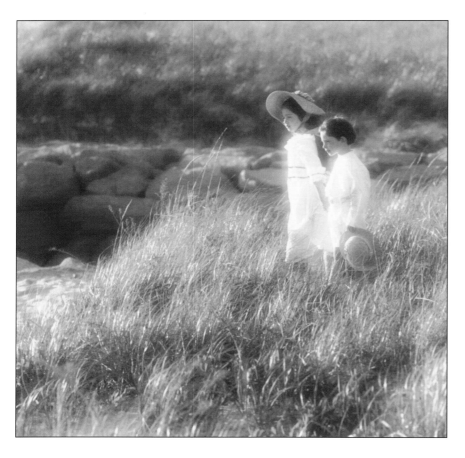

11-2 (left): Stronger directional lighting will cause the soft focus to make white elements glow (called halation). The sun coming in at a front or side angle works. An angle from behind the subject can make it difficult to distinguish detail. Photo by Helen T. Boursier.

11-3 (below): Printing black & white from color creates a little more grain and a special effect look. The light dresses and high ratio lighting add enough contrast when the image is transferred to black & white paper. Photo by Helen T. Boursier.

11-4 (right): "Splash Dance" won a Kodak Gallery Award in the illustrative category. It was taken with a vinyl edge vignetter and a Nikon One soft focus filter. To enhance the high key effect, I opened up the camera two stops brighter than the light meter reading suggested for a "correct" exposure. One stop would compensate for all the diffusion and the second stop created the brighter look. Photo by Helen T. Boursier.

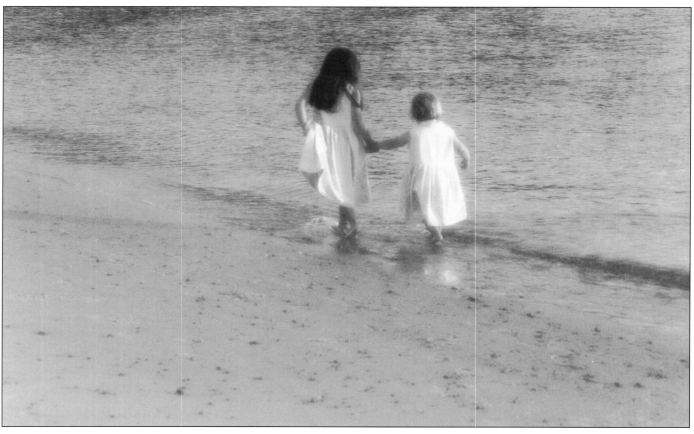

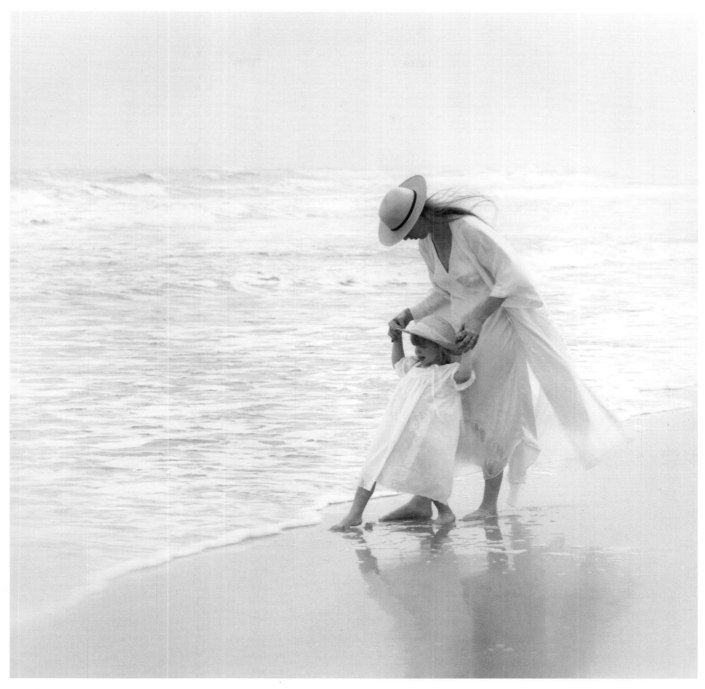

If you take an image in color and then print it as a black & white, you'll increase the grain structure slightly. Or, during the printing, you can also use an official texture screen or make your own with just about any translucent material.

If you place a texture material against the negative, you can enlarge all the prints with the same texture look for 8x10 and smaller prints. When enlarging anything bigger, you should place the screen material directly on the photographic paper.

11-5 (left): The Nikon One soft focus filter allows for plenty of black blacks and white whites when used with a traditional soft box and reflector. Hair lights and back lights can create the halation glow. Photo by Helen T. Boursier.

11-6 (below): "Family Stretch" was taken on color film with a Nikon One soft focus filter on an overcast day so there is not enough "pop" when it is printed on black & white paper. Photo by Helen T. Boursier.

11-7 (right): An edge diffuser keeps the subject sharp and the edges soft. Make sure the subject is in the middle of the image. It will look distorted if a head or foot goes into the diffused area. Photo by Helen T. Boursier.

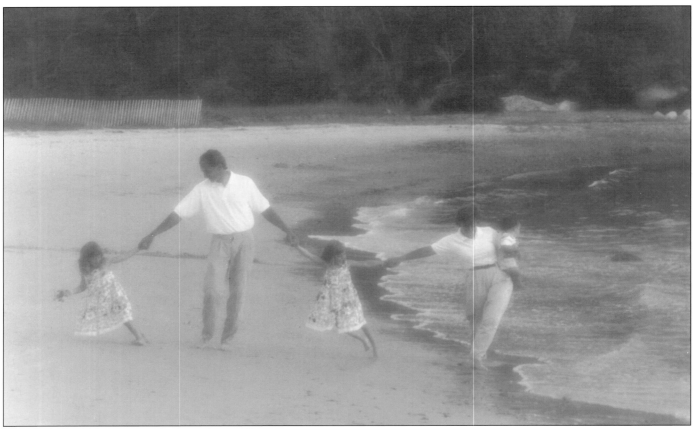

11-8 (left): Experimenting with high speed film and extreme close-ups. Photo by Paul Bobkowski.

11-9 (below): The photographer used experimental lighting to create this shot. Don't be afraid to try new things and to experiment. Photo by Paul Bobkowski.

11-10 (right): The photographer was experimenting with alternative printing processes when he created this self-portrait using a photographic product called Liquid Light. It is available from a photo supply store and brushes on to virtually any surface. After the emulsion sets up, you print on it as you would regular paper. This image was taken with window light against a backdrop of a parachute he picked up at an Army surplus store. Photo by Jay Goldsmith.

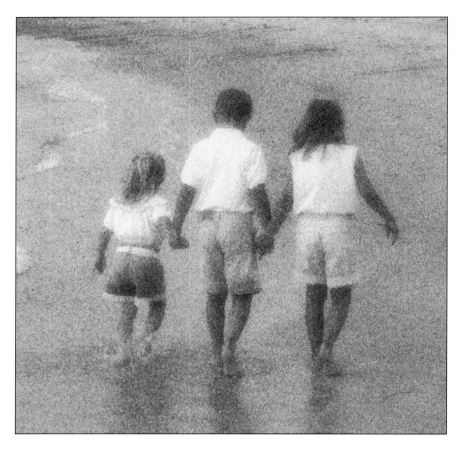

11-11 (left): Grain texture screen from Texture Effects (TM) placed directly on photographic paper during printing. The image was taken with Kodak Tri-X film and a Nikon One soft focus filter. Photo by Helen T. Boursier.

11-12 (below): Create a moodier image with darker printing and a different type of texture. The same image was printed with a piece of iron on interfacing available in a fabric store. Photo by Helen T. Boursier.

11-13 & 11-14 (opposite page, top & bottom): The on-camera look taken on an overcast day with no diffusion (top) has a completely different feeling from the same setting with a Nikon One soft focus filter and the children looking off-camera (bottom). The flat light makes the diffusion reduce the contrast more than usual. Photo by Helen T. Boursier.

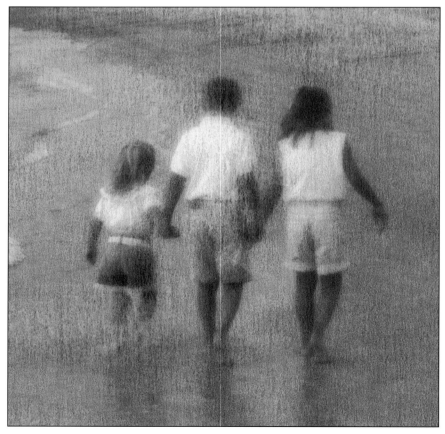

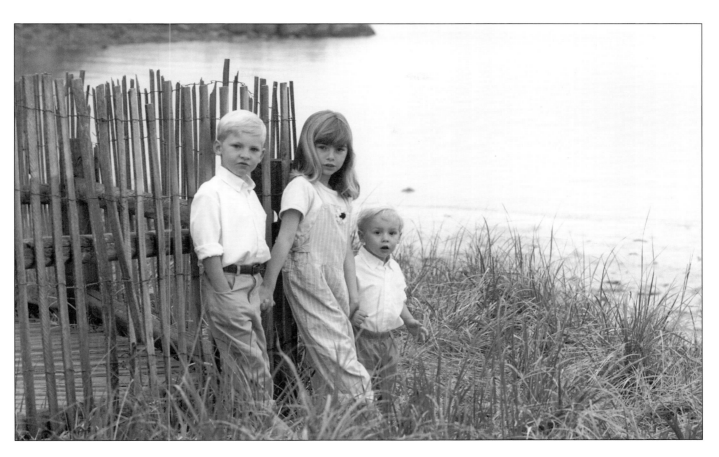

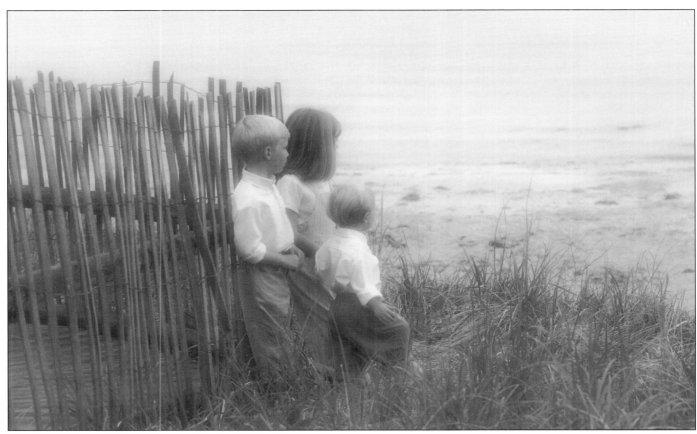

CHAPTER TWELVE

Working with a Lab —
or Doing it Yourself

"Time is why many others use a full service or speciality lab."

Control is the key reason most photographers choose to process and print all their black & white work. Time is why many others use a full service or specialty lab. Those who do all the darkroom work in-house struggle to find the time, and those who farm the work to a lab struggle to control the finished product.

When we first launched black & white into our market area, we had limited darkroom space. Our darkroom technician did a limited amount of film processing, contact printing, and tray development for prints 8x10 and smaller.

We farmed out all the work for 11x14 and larger. The small print quality from the work produced by our technician was so superior to the various lab-produced work that he gradually expanded the sizes he was able to print. He slowly purchased equipment to enable him to produce large prints in a small darkroom. Now he does all the developing, slide proofs, 8x10 and smaller tray processed prints, and wall portraits up to 24x30 processed in large tubes.

His main objective is to make all his film processing and developing consistent. "Consistency" translates into "repeatable" when a client returns for another enlargement from a previously printed negative. Repeatable work saves time and prevents waste.

John Ouellette does all his own developing and printing. He tray processes his paper individually and pushes the temperature times to get a warmer image. For example, instead of the normal 68°, he might print with the chemicals 75° — 80° or even higher to get a warmer image on the fiber-based paper.

His advice is: "Don't rely on someone else to do the work for you. You have to do it yourself to get the results you will like best. Experiment with all kinds of film and papers. Then, once you find a paper you like, stick with it. Learn its strengths and limitations. Then you will be able to deliver a consistent quality product every time."

Choosing a lab to process and/or print your black & white depends heavily on the brand and type of photographic paper it uses and the sizes of enlargements it offers. Where color is more or less standardized, black & white offers more variations.

12-1 & 12-2 (opposite page, top & bottom): The silhouette of a family on the beach could be printed as a true silhouette with the people dark against the water. Or it could be printed with the people light and the water bright for an almost high key effect. The darker printing (bottom) is technically correct and would be the automatic choice of the lab. However, "correct" to the client might be the lighter version. Good communication with the lab is critical to avoid time-wasting reprints. Photo by Helen T. Boursier.

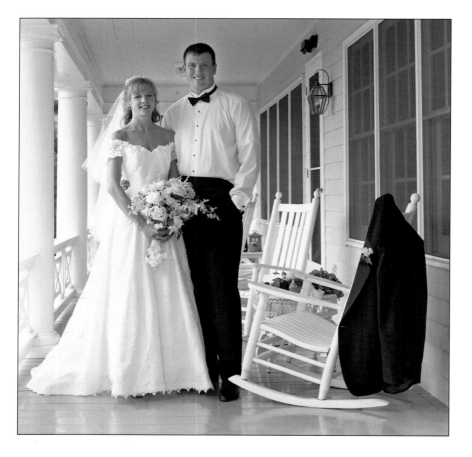

12-3 (left): Russell prefers spending time with clients rather than in the darkroom. When you don't have control over the printing, she suggests asking the printer at your lab which film he or she prefers to work with. She says following the printer's recommendations will give you better results. Photo by Julia Russell.

12-4 (below): It would be almost impossible to use contact sheets or paper proofs to choose the overall favorite image for a group this large. We have the Tri-X film processed, then copied onto Kodak Technical Pan film which creates a "positive" slide proof. The images are then projected on the wall in a 30x40 size so clients can easily choose their favorite poses and best expressions. Photo by Helen T. Boursier.

12-5 (right): Ouellette does his own negative retouching and printing to produce his signature look Photo by John E. Ouellette.

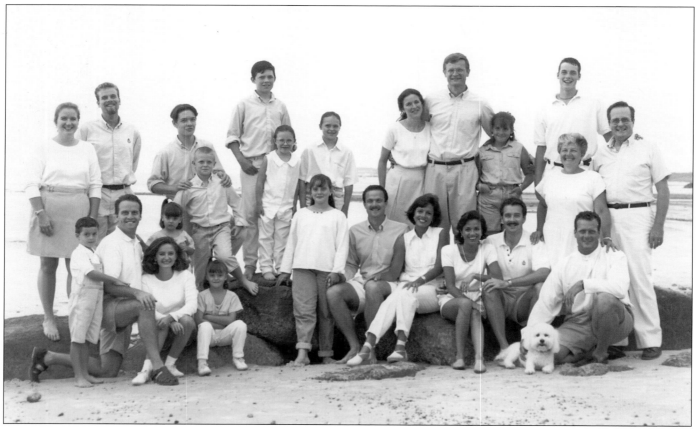

For example, you could find a small specialty lab that prints only on fiber-based paper and does enlargements only up to 20x24. It probably does not offer mounting services, negative retouching, or print enhancement. When the day comes that you sell a larger size, want a canvas sample, or need blemishes removed from a black & white negative, you have to scramble around to find another source or figure out how to do the work yourself.

The full service color lab that also offers black & white might have the same limitations as the independent lab in terms of sizes offered and type of paper used. However, the big lab will be able to take care of your negative and print retouching as well as mounting services.

The key to working with either the small or the large lab is to identify your goals. What do you want to offer your clients? What services do you expect to use? If a prospective lab doesn't currently offer a service you need, would they be willing to make an exception and provide the service for you? Can you locate a place to sub-contract the work to an even smaller independent lab? Ask around until you find a lab that can provide the services you need.

"Ask around until you find a lab that can provide the services you need."

12-6 : (right) Goldsmith has the capacity to print his own work, but he has a small speciality lab do most of his printing so he has more time to work with clients. Photo by Jay Goldsmith.

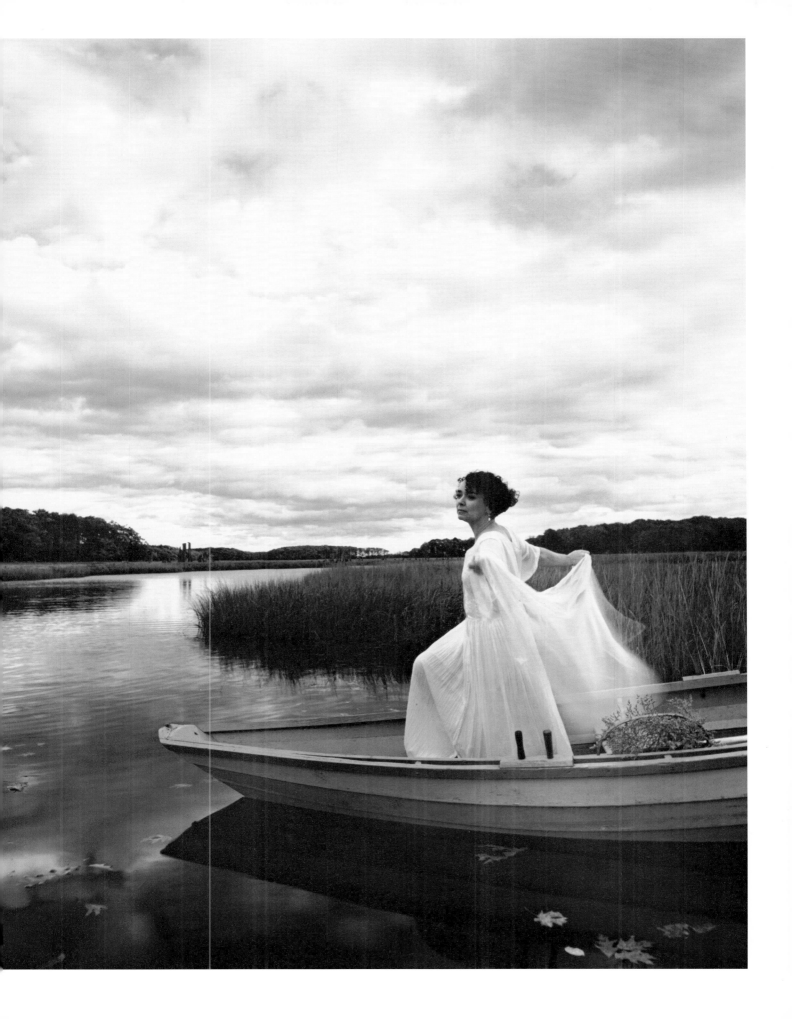

CHAPTER THIRTEEN

Packaging Your Black & White Portraits

I used to charge more for handcolored black & white then for straight black & white or regular color. Then, I realized that I was doing a tremendous amount of finish work on each image, whether it was color tones (on black & white) that the client could see, or gray tones to enhance the detail

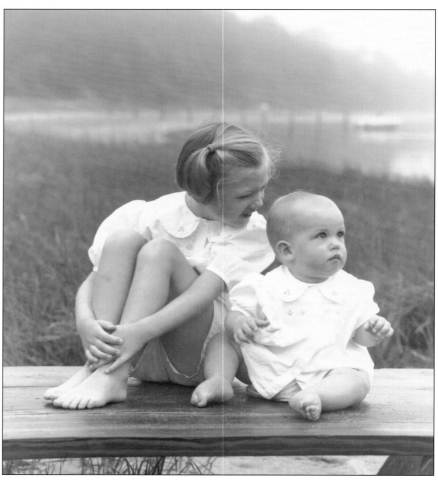

13-1: Photograph a variety of poses, styles, settings and feelings within one session to allow your client greater flexibility when it comes to making the final selection. Photo by Helen T. Boursier.

of a classic black & white image. Because the time invested was basically the same for a tinted image as for a straight black & white, I began charging the same price for both styles.

Another issue to work through is print size — which sizes to offer and which sizes to handcolor. I originally offered handcoloring for all sizes from 4x5 album inserts to 30x40 wall portraits. I found, however, that those little images are just as time-consuming to tint as the larger ones. Now I handcolor only 11x14 and larger.

Jay Goldsmith presents his wall portrait black & white images matted and framed under glass. Since the images are going to be matted and therefore larger overall, his clients usually choose a 16x20 or several 11x14s. John Ouellette offers 5x7 to 20x24. His most popular black & white product is 11x14 on fiber-based paper. He mounts the photographs on flat board and the client takes it elsewhere for framing.

Richard Barnes does mostly color portraiture, but he has favorite black & white images from personal projects displayed in the reception room. He says that those who ask for black & white usually have a portrait design concept in mind. Everything he offers in color is also offered in black & white, from a 2x3 wallet to a 40x60 canvas wall portrait.

13-2: Perfect family portraits require teamwork. The subjects must coordinate clothing and schedules. The photographer must capture natural expressions in a posing style that reflects the true spirit of the subjects. Photo by Helen T. Boursier.

13-3 (left) Mat collections are a popular way to display small portraits of "runner-up" favorite poses. This end table style features three 5x7s.

13-4 (below): The canvas collection on the left side of the photo features one 11x14, two 8x10s, and three 5x7s on canvas. The frames are connected so it hangs as one piece. The portrait on the right side of the photo is 20x24.

13-5 (left): This is our front reception room at Boursier Photography.

13-6 (below): And here is the Boursier show room where clients view slide proofs and select their favorite images.

13-7: The frame display at Boursier Photography.

Martin A. Seefer's business is also geared toward color photography, but many of his brides request black & white bridal formals as well as some black & white wedding day coverage. Seefer charges 20% more (based on the custom color price) for a black & white image. His brides particularly like to have their bridal study session displayed in a presentation folio with eight 4x5 photographs.

Wedding photographers Julia Russell and Cheryl Richards include most of their black & white images in the wedding album with reorder photographs, generally 8x10 and 5x7.

Black & White Portraits on Canvas

The majority of our black & white images go out on canvas. The paper backing is removed and the photographic emulsion is lined up with the grain of a fine art canvas. Then, through heat and pressure, the photograph is permanently embedded in the canvas. From the front, it adds the obvious texture pattern. That texture adds depth and dimension to the portrait. A light artist's glaze protects the surface and frames each image around the edges without matting or glass.

We offer the canvases as individual wall portraits or as a group — with an entire family in the largest size, the children in a complementary size, and individual shots of the children in an accent size, perhaps on a different wall across the room.

"The majority of our black & white images go out on canvas."

13-8: *Appreciate how much planning and effort go into each portrait for your clients. Photo by Helen T. Boursier.*

The collections combine the visual appeal of wall portraits but with a storytelling feel. We also offer album collections. Clients may choose a 4x5, 8x8, or 8x10 format album. Many clients have a large wedding style album that they add pages and portraits to through the years. Your clients' family stories can literally unfold in the pages of those albums.

Putting It All Together

Let your samples do the talking. Be excited about talking about your work, but back up the talk with samples. Our reception room looks like a living room and the walls feature a variety of black & white handcolored canvas portraits.

The sizes balance the furniture and the number of people in the portraits. The larger portraits are samples of large family groups, and the smaller portraits are of fewer people and hang on smaller walls.

All of the images are black & white on canvas. To help my clients better visualize handcoloring, some of the images are lightly tinted, others "medium" tinted, one "dark" tinted and one classic black & white. I can easily show the differences so clients can decide which look they like best. If you offer framing, be sure to display samples of portraits matted and framed under glass.

However you express it, you need to believe in your work. And, you need to understand what your clients go through when they get everything organized for a portrait session. Appreciate how much planning and effort go into each family portrait for your clients. There may be some stress along the way, but the end portrait is always worth it.

"Let your samples do the talking."

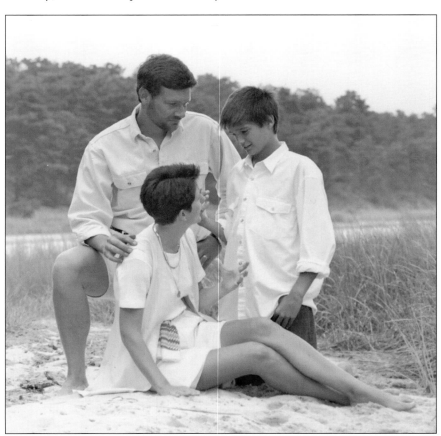

13-9: I once asked my teenage son how far back his memories went of his childhood. He said, "With the photographs, I remember a lot." Portraits are about freezing the moment today, so you can remember a lot tomorrow. Photo by Roberta Cloutier.

Conclusion

My advice, and that from the photographers featured throughout this book, is virtually the same: Shoot a lot of film, experiment with style until you find one that fits you, learn everything you can about the film and paper you choose to use, and practice! The ultimate aim — a beautiful black & white portrait — is worth the effort.

Thomas Edison once said, "If we did half the things we were capable of doing, we would literally astonish ourselves." Take the ideas that work for you, and astonish yourself!

"...experiment with style until you find one that fits you..."

Appendix

Contributing Photographers

Richard and Kristen Barnes
Box 446
E. Brookfield, MA 01515
(508)867-5260

Michael and Helen Boursier
74 Carol Avenue
Falmouth, MA 02540
(508)540-3950

Paul Bobkowski
46 Barnes Avenue
Worcester, MA 01615
(508)852-5054

Dean Collins
2010 Garrison Way
El Cajon, CA 92019
(619)447-1169

Jay Goldsmith
32 Cottage St.
Portsmouth, NH 03801
(603)431-4139

Horace Holmes
352 Cotton Ave.
Macon, GA 31201
(912)741-5151

Roy Madearis
1304 W. Abram
Arlington, TX 76013
(817)277-0759

John Ouellette
998 Farmington Ave. Suite 101
W. Hartford, CT 06107
(860)233-8289

Cheryl Richards
75 Webster St.
Worcester, MA 01603
(508)793-8722

Julia Russell
32 Cottage St.
Portsmouth, NH 03801
(603)431-4139

Martin A. Seefer
290 Burnside Ave.
E. Hartford, CT 06108
(860)528-1321

Supplier List

We use the following list of suppliers for assorted wholesale items. Call or write for information.

Oval mounts to mask over slide proofs:
Jiffy Mask
The Kinney Co.
Box 1229
Mt. Vernon, WA 98273

Canvas supplier (mounting and/or materials):
Tara Materials
Box 646—111 Fredrix Alley
Lawrenceville, GA 30246
(404)963-5256

Negative retoucher:
Robin Cavalia
(602)730-9959

Bubble wrap (for shipping completed portraits):
National Bag
(800)247-6000

Corrugated boxes/office supplies:
Quill Corp.
(800)789-1331

Pretty delivery boxes:
NPD Box
(800)969-2697

Framing do-dads and poly bags:
United Mfgrs. Supplies Inc.
(800)645-7260

Christmas cards/stationery for photographs:
M&M Designs Inc.
Houston, TX
(713)461-2600

Music/keepsake boxes with photo:
Kimberly Enterprises
(800)521-8931

Top quality custom postcards/notecards:
Dynacolor Graphics Inc.
(800)624-8840

Frame corners:
Gemini Moulding Inc.
(800)323-3575

Larson-Juhl
(800)438-5031

Custom cut matting:
Light Impressions
(800)828-6216

Pre-cut custom looking mattes:
Crescent Cardboard Co.
(800)323-1055

Oval frames:
Presto Frame and Moulding
(800)431-1622

Copyright stamp for back of photos:
Schwaab
(414)771-4150

Portable VISA/MC machine (called a "Mini Mate"):
Bartizan Corp.
(914)965-7977

Full service b&w labs:
Filmet
2103 Hampton St.
Pittsburgh, PA 15218
(412)731-1600

Sound Color
Harbour Pointe Bus. Ctr.
4711 116th St. SW
Mukilteo, WA 98275
(800)426-9262

Specialty b&w custom lab:
Jonathan Penney — Darkroom Services
6 Adelaide Park
Center Moriches, NY 11934
(516)874-3409

Promise of Excellence portrait guarantee program:
Eastman Kodak
Professional Photography Division
(800)717-4040

For information on Helen Boursier's current speaking/
workshop schedule, contact:
 Boursier Publications
 FAX (508)540-6243

Other Books by Helen T. Boursier

The Modern (Hand Tinted) B&W Portrait (Studio Press)

The Studio Sales Manual (Studio Press)

Marketing Madness (Studio Press)

Tell It With Style (InterVarsity Press)

The Cutting Edge (Boursier Publications)

Interviews with Forty Photographers (Boursier Publications)

Top Ten Marketing (Boursier Publications)

Suggested Reading

Walking On Water—Reflections on Faith and Art
by Madeleine L'Engle (Harold Shaw Publishers)

The Artist's Way
by Julia Cameron (Tarcher Putnam Publishing)

William Mortensen photography books — everything from
negative to pictorial to lighting to print finishing.

Amherst Media photography books — everything from wedding photography to lighting to infrared photography.

Glossary

Aperture: Photographers commonly refer to this as f-stop. It is the opening in the lens that admits light.

Available Light: The existing light, natural or artificial, indoors or outdoors, that is already there. Photographers use available light as the primary source to light the subject or as the secondary source to fill in the shadows.

Back Light: The available light coming from behind the subject and shining directly toward the camera.

Bounce Flash: A technique of softening the light from a flash or strobe unit by directing it to a ceiling, wall or off a piece of photographic equipment like an umbrella or a soft box.

Depth of Field: The area of acceptable sharp focus in a picture. It includes the area in front of and behind the subject that is in focus. Many portrait photographers prefer a shallow depth of field, often just the eyes or the face of the subject to enhance impact.

Diffused Light: Light loses some of its intensity when it passes through a transparent or diffused material. Heavy overcast skies diffuse the light from the sun, for example.

Exposure: The total amount of light allowed to pass through the lens to the film as controlled by the aperture size and the shutter speed.

Film Speed: A film's sensitivity to light, rated numerically. The higher the ASA film speed rating, the faster the film. Faster film requires less light to create exposures on the film.

Filter: A thin sheet of glass, plastic or gelatin placed in front of the camera lens to change the appearance of the image as it is being recorded in the camera.

Fill Flash: An expression that means to slightly fill the shadows in an outdoor portrait.

Flash: A very brief but intense flash of artificial light.

Grain: The granular texture that appears to some degree in all processed photographic materials.

Handcoloring: Adding color to a black & white photograph by hand with pencils, pastels, watercolors, wet dyes, dry dyes or oils.

Key: A term used to describe the tone or colors of a photograph. High key refers to an all light or white setting. Low key refers to an all dark or black setting.

Kicker Light: An accent light where one side of the subject is illuminated more strongly than any other area of the image. Sometimes referred to as a rim light.

Rim lighting: A form of lighting where the subject appears outlined with light against a dark background. It is often used to accent one side of the subject.

Shutter: The camera mechanism that controls the duration of the exposure. A slow shutter speed means the subjects must sit very still or their movement will cause the image to look out of focus and blurred.

Silhouette: When a person or object is photographed against a strong light, the resulting black image is a silhouette.

Slide Proofs: The method many portrait photographers use to show clients proofs. The lab takes the processed film (35mm or 120 format) and copies it onto 35mm slide film. The slides are projected on the wall for easy viewing and pose and size selection. Then the negatives are used to make the enlargements.

Soft Box: A soft fabric box (usually flame resistant nylon), with a transparent front, that contains an electronic flash unit. It produces a "soft" natural looking light for photographing models.

Soft focus: Deliberately diffusing or blurring the definition of an image, usually to create a dreamy or romantic mood.

Stop: A comparative measure of exposure. Each standard change of the shutter speed or aperture represents a stop and doubles or halves the light reaching the film.

Transviews: Another word for slide proofs.

TTL: The abbreviation for "through the lens" and generally refers to the exposure metering system to sync the flash unit to the camera.

Tripod: A three-legged camera support. Bigger cameras, like a Mamiya RB67, require a stronger, heavier tripod to support the weight of the camera.

Umbrella Reflector: An actual umbrella that is lined with material (white, gold and silver), in which an electronic flash can be reflected. The resulting light can be directed at a model, producing varying degrees of softness and intensity.

Zoom Lens: A lens of variable focal lengths. For example a 100-200mm zoom lens has a focal length that can be changed any where between 100mm and 200mm.

Index

Other Books from
Amherst Media, Inc.

Wedding Photographer's Handbook

Robert and Sheila Hurth

A complete step-by-step guide to succeeding in the world of wedding photography. Packed with shooting tips, equipment lists, must-get photo lists, business strategies, and much more! $24.95 list, 8½x11, 176p, index, b&w and color photos, diagrams, order no. 1485.

Lighting for People Photography, 2nd ed.

Stephen Crain

The up-to-date guide to lighting. Includes: set-ups, equipment information, strobe and natural lighting, and much more! Features diagrams, illustrations, and exercises for practicing the techniques discussed in each chapter. $29.95 list, 8½x11, 120p, b&w and color photos, glossary, index, order no. 1296.

Outdoor and Location Portrait Photography

Jeff Smith

Learn how to work with natural light, select locations, and make clients look their best. Step-by-step discussions and helpful illustrations teach you the techniques you need to shoot outdoor portraits like a pro! $29.95 list, 8½x11, 128p, b&w and color photos, index, order no. 1632.

Wedding Photography:
Creative Techniques for Lighting and Posing

Rick Ferro

Creative techniques for lighting and posing wedding portraits that will set your work apart from the competition. Covers every phase of wedding photography. $29.95 list, 8½x11, 128p, b&w and color photos, index, order no. 1649.

How to Operate a Successful Photo Portrait Studio

John Giolas

Combines photographic techniques with practical business information to create a complete guide book for anyone interested in developing a portrait photography business (or improving an existing business). $29.95 list, 8½x11, 120p, 120 photos, index, order no. 1579.

Professional Secrets for Photographing Children

Douglas Allen Box

Covers every aspect of photographing children on location and in the studio. Prepare children and parents for the shoot, select the right clothes capture a child's personality, and shoot story book themes. $29.95 list, 8½x11, 128p, 74 photos, index, order no. 1635.

Handcoloring Photographs Step-by-Step

Sandra Laird & Carey Chambers

Learn to handcolor photographs step-by-step with the new standard in handcoloring reference books. Covers a variety of coloring media and techniques with plenty of colorful photographic examples. $29.95 list, 8½x11, 112p, 100+ color and b&w photos, order no. 1543.

Family Portrait Photography

Helen Boursier

Learn from professionals how to operate a successful portrait studio. Includes: marketing family portraits, advertising, working with clients, posing, lighting, and selection of equipment. Includes images from a variety of top portrait shooters. $29.95 list, 8½x11, 120p, 123 photos, index, order no. 1629.

The Art of Portrait Photography

Michael Grecco

Michael Grecco reveals the secrets behind his dramatic portraits which have appeared in magazines such as *Rolling Stone* and *Entertainment Weekly*. Includes: lighting, posing, creative development, and more! $29.95 list, 8½x11, 128p, order no. 1651.

Photographer's Guide to Polaroid Transfer

Christopher Grey

Step-by-step instructions make it easy to master Polaroid transfer and emulsion lift-off techniques and add new dimensions to your photographic imaging. Fully illustrated every step of the way to ensure good results the very first time! $29.95 list, 8½x11, 128p, order no. 1653.

Wedding Photojournalism

Andy Marcus

Learn the art of creating dramatic unposed wedding portraits. Working through the wedding from start to finish you'll learn where to be, what to look for and how to capture it on film. A hot technique for contemporary wedding albums! $29.95 list, 8½x11, 128p, order no. 1656.

Studio Portrait Photography of Children and Babies

Marilyn Sholin

Learn to work with the youngest portrait clients to create images that will be treasured for years to come. Includes tips for working with kids at every developmental stage, from infant to pre-schooler. Features: lighting, posing and much more! $29.95 list, 8½x11, 128p, order no. 1657.

Photographer's Guide to Shooting Model & Actor Portfolios

CJ Elfont, Edna Elfont and Alan Lowry

Learn to create outstanding images for actors and models looking for work in fashion, theater, television, or the big screen. Includes the business, photographic and professional information you need to succeed! $29.95 list, 8½x11, 128p, order no. 1659.

Fine Art Children's Photography

Doris Carol Doyle

Learn to create fine art portraits of children in black & white. Included is information on: posing, lighting for studio portraits, shooting on location, clothing selection, working with kids and parents, and much more! $29.95 list, 8½x11, 128p, order no. 1668.

Infrared Portrait Photography

Richard Beitzel

Discover the unique beauty of infrared portraits, and learn to create them yourself. Included is information on: shooting with infrared, selecting subjects and settings, filtration, lighting, and much more! $29.95 list, 8½x11, 128p, order no. 1669.

Photographing Children in Black & White

Helen T. Boursier

Learn the techniques professionals use to capture classic portraits of children (of all ages) in black & white. Discover posing, shooting, lighting and marketing techniques for black & white portraiture in the studio or on location. $29.95 list, 8½x11, 128p, order no. 1676.

Marketing and Selling Black & White Portrait Photography

Helen T. Boursier

A complete manual for adding b&w portraits to the products you offer clients Learn how to attract clients and deliver the portraits that will keep them coming back. $29.95 list, 8½x11, 128p, order no. 1677.

Infrared Wedding Photography

Patrick Rice, Barbara Rice & Travis Hill

Step-by-step techniques for adding the dreamy look of black & white infrared to your wedding portraiture. Capture the fantasy of the wedding with unique ethereal portraits your clients will love! $29.95 list, 8½x11, 128p, order no. 1681.

Studio Portrait Photography in Black & White

David Derex

From concept to presentation, you'll learn how to select clothes, create beautiful lighting, prop and pose top-quality black & white portraits in the studio. $29.95 list, 8½x11, 128p, order no. 1689.